THEN & NOW

MOUNT PLEASANT

Opposite: Transport trucks were manufactured at a Pickard Street Mount Pleasant plant, which started in 1919 and closed in 1925 after having produced about 1,000 trucks, including the 1919 Mount Pleasant fire truck on page 78. One of the company's first and biggest promotions was a circle tour of Lake Superior by its whole line of trucks. The baggage lorry is shown on the opposite page.

MOUNT PLEASANT

Jack R. Westbrook

TRANSPORT
ONE-TON
1921 "AROUND LA
MICHIGAN PIKE
TRANSPORT TRUC
MOUNT PLEASA
BAGGAGE LORRY

WILSON
BUILT
BODY

For my wife, Mary Lou, with deep appreciation and admiration
for her patience and support through a 47-year (so far) adventure that has seen
us launch five functional human beings (Lydia, Collette, Steve, Paula,
and Mary) along their chosen paths.

Library of Congress control number: 2006933274

Published by Arcadia Publishing
Charleston SC, Chicago IL, Portsmouth NH, San Francisco CA

Printed in the United States of America

For all general information contact Arcadia Publishing at:
Telephone 843-853-2070
Fax 843-853-0044
E-mail sales@arcadiapublishing.com
For customer service and orders:
Toll-Free 1-888-313-2665

Visit us on the Internet at www.arcadiapublishing.com

On the front cover: The south side of East Broadway Street contained J. C. Penney Company, Voisin's Jewelry, Clabuesch Drug, Crapo Insurance Agency, Thompson's Jewelry, Bickert's Ladies Apparel, and the Exchange Savings Bank in the 1940s. Now the same area, with National City Bank occupying the first three storefronts from the right and the Mount Pleasant Area Chamber of Commerce second from the left, serves as a backdrop for a casual outdoor lunch for, from left to right, Joyce Castellon, Kim Nelson, Marlene Hanley, Judie Swartz, and Heidi Castellon at Max and Emily's Eatery. (Above, author's collection; below, courtesy of the Norman X. Lyon Collection, Clarke Historical Library

On the back cover: Please see page 19. (Courtesy of the Norman X. Lyon Collection, Clarke Historical Library.)

Contents

ACKNOWLEDGMENTS

Thanks to the framers of fortune who have blessed me with the path to this project. It started when my sixth-grade teacher, Jack Anson, had the class publish a student newspaper, sparking my love of generating the printed word. I am grateful to my high school English teacher Tom Northway, whose classes in journalism included putting out a bimonthly student newspaper and a yearbook. Tom taught me the inevitability of mistakes but underlined their true value: what you learned from the experience. Residents of Mount Pleasant made living there memorable enough to want to preserve it and further enhanced the desire to produce this book so future researchers could see the folk of central Michigan at work and play.

Specific to this project, thanks go to Arcadia Publishing acquisitions editor Anna Wilson and publisher John Pearson (in the Chicago office) and to publicity manager Adie Lee and regional sales manager Meg Firebaugh (in the Mount Pleasant, South Carolina, office) for their help in bringing about this book. I am grateful to director Frank Boles, archivist Marian Matyn, reference librarian John Fierst, and scanning/digitizing specialist Pat Thelan of the Clarke Historical Library at Central Michigan University for helping to find and prepare many photographs for publication. Special thanks go to *Mount Pleasant Morning Sun* executive editor Rick Mills, who posed for the Linotype image on page 77. Additional thanks go to the following: Mount Pleasant Area Historical Society members Sherry Sponseller and Shirley Bragg for sharing their photograph collections (Sherry supplied many of the 1950s-era shots, while Shirley provided the vintage passenger depot image on page 88); Mount Pleasant Municipal Airport manager John Benzinger for the present-day airport photograph; city clerk Rob Flynn for some 1988 downtown shots and the identifications of others; and Jack Neyer and Bill and Bob Cook for tracking down other images used here. I am grateful to Hudson Keenan, the real expert on Mount Pleasant history, for reviewing this work for historical inaccuracies.

Above all, thanks go to my 35-year friend, the late Norman X. Lyon, who was alternately editor of the *Michigan Oil & Gas News* and the *Mount Pleasant Daily Times-News* from 1929 until 1972, whose sage advice and counsel often led to accomplishing some things beyond my own expectations, and whose vast collection of photographs has aided many of my historical projects, of which this book is the latest.

INTRODUCTION

No book this small could begin to capture the images touching all aspects of this central Michigan village that became a city. Two previous Arcadia Publishing books have examined three major facets of Mount Pleasant life. William Cron's *Mount Pleasant* leaned heavily on the saga of the Chippewa Indian tribe and Central Michigan University's influence on the town. My own *Michigan Oil and Gas* told the story of the industry that spared Mount Pleasant from the Great Depression. This book will concentrate on downtown and the nucleus of town life until about the early 1960s, with only an occasional foray into nearer dates.

I had accumulated more than 500 historical photographs of Mount Pleasant after completing another project and sought to "fill in some holes" for this book from photographs in local libraries. Searching conventional sources revealed a dearth of organized Mount Pleasant historical photographic files. Even with what I was able to find, there are still some valuable images not available in a central source.

That situation is being remedied by the Mount Pleasant Historical Society, which is now launching a program to appeal to the townsfolk to lend their vintage photographs to the society long enough to be scanned and included in a photographic searchable index to be made available to area libraries as a reference tool. So, precious reader, thanks for lending your support to that project by your interest in this book, the seed from which the project grew. If you have vintage Mount Pleasant photographs, electronic or hard copy, please contact me at JackwestbrookMtP@aol.com.

Mount Pleasant rests in the palm of the Michigan mitten, 17 miles northwest of the geographical center of Michigan's Lower Peninsula, at the crossroads of U.S. Route 127 and Michigan Route M-20. The Chippewa River runs through it, bisecting the town on its way to confluence with the Tittabawasee River and ultimately the Saginaw River and Saginaw Bay. Near downtown, the river splits and rejoins itself, forming Island Park, which with Nelson, Millpond, and Chipp-A-Waters Parks forms a green corridor along the river through the southwestern third of the city.

Mount Pleasant came into being when lumberman David Ward platted the town and donated a lot to be used for a county courthouse. Since there are no mountains near, two theories explain the origin of the city name: one saying that the high bank of the Chippewa River near Island Park was the greatest elevation change in the area, appearing mountainlike to early river travelers, and the other claiming that the central Michigan area reminded Ward of Mount Pleasant, New York, his home during his youth.

Mount Pleasant's year-round population of 27,000 is augmented during the school season by around 20,000 students of Central Michigan University and an estimated 25,000 visitors daily to the Soaring Eagle Casino and Resort on the Saginaw Chippewa Indian Reservation east of town. Merchandising giants Wal-Mart, K-Mart, Target, and Meijer chose Mount Pleasant to be the first small city in the United States in which to go head-to-head a decade ago, making the community a "shoppers dream without the big town hassle" of central Michigan and adding to visitor volume.

It is a growth community with apartment, shopping, entertainment, hotel, and restaurant complexes having sprung up in the surrounding fields like dandelions in a balmy spring. But such was not always the case, particularly in the late 1920s.

Lumber, farming, and mercantile marketing, later joined by Central Michigan Teachers College, were the principal industries of the fledgling Mount Pleasant, with the opening of the railroad

adding to the growth. Despite its central location, manufacturing as a large employer never came to be in Mount Pleasant. Herbert Dow had chosen to sink his brine wells and found Dow Chemical Company 25 miles east at Midland.

The economy of Mount Pleasant was relatively stable and static for decades.

The 1928 discovery of the Mount Pleasant oil field between Mount Pleasant and Midland proved that the Michigan geological basin fringe fields at Saginaw (1925) and Muskegon (1927) were not geological flukes, and oil in great quantities could be produced at the center of the state. The rush was on. Overnight Mount Pleasant became a boomtown and flourished with new residents from all over the nation, new housing, new businesses, and, best of all, new money. Mount Pleasant stayed prosperous while the rest of the nation was plunged into the economic quagmire of the Great Depression in 1929. The town adopted the motto, still in use, "Oil Capital of Michigan." While the drilling action has moved to other parts of the state, oil field businesses remain in Mount Pleasant, and the industry is still a force in Mount Pleasant life—the high school athletics teams carry the name the Oilers.

In 2006, the largest employer is the Soaring Eagle Casino and Resort, grown from humble beginnings as a bingo venue in the 1970s on the Saginaw Chippewa Indian Reservation just east of Mount Pleasant to become the largest casino in the midwestern United States.

I hope you like our town now as much as we liked it then.

DOWNTOWN

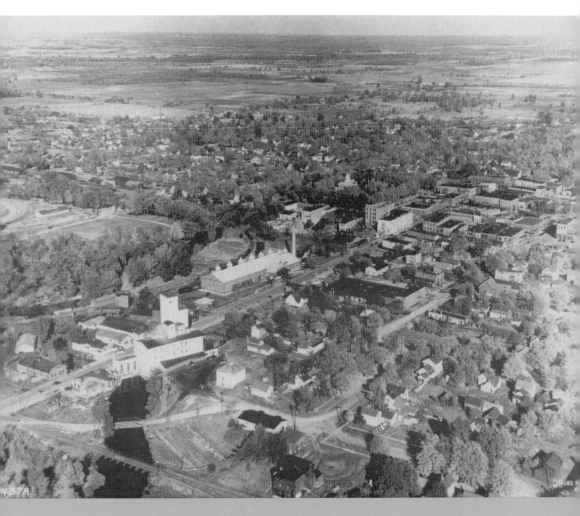

Looking northeast at 1937 downtown Mount Pleasant, this aerial view shows government, shops, jobs, entertainment, and homes comprising the town's nucleus, all within a few blocks of one another. In the upper quarter, Mission Street would blossom into a commercial/retail corridor. To the right middle and out of the frame is Central Michigan College, and to the upper right, also out of the frame, is the Saginaw Chippewa Indian Reservation.

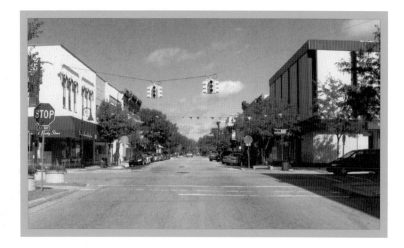

The corner of the Donovan House hotel, left, frames the dirt road that was Broadway Street in Mount Pleasant of the 1890s, in this eastward view from just west of the Main Street intersection. The form of the downtown building infrastructure of East Broadway's 100 block was beginning to take shape. The Donovan House became the Park Hotel, which was razed in the 1960s to become the start of the Town Center, a landscaped open area.

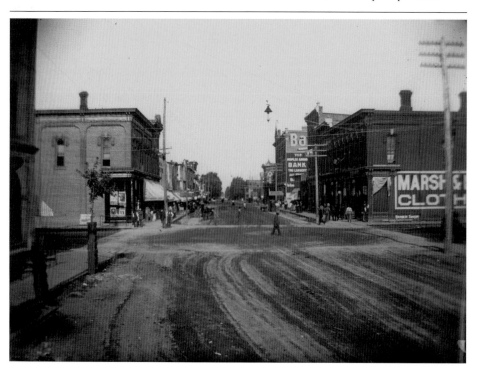

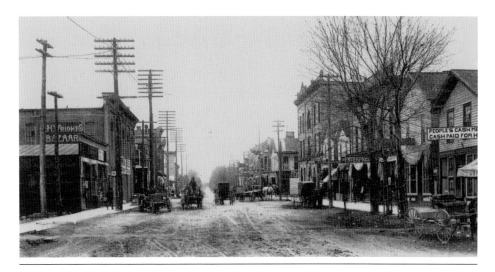

In the view above, looking south from the corner at 200 North Main Street, the crossing of Broadway Street forms the main intersection of 1906 downtown Mount Pleasant and is distinguished by the hanging light fixture at the center. Below, in 2006, the buildings at the near right are gone, while those on the left are still distinguishable with the nearest now housing the Daily Grind Coffee Shop and Pisanello's Pizza. The Main-Broadway intersection is marked by the center set of traffic lights.

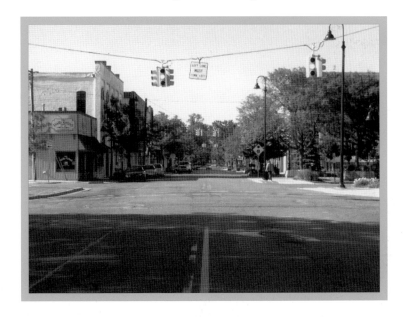

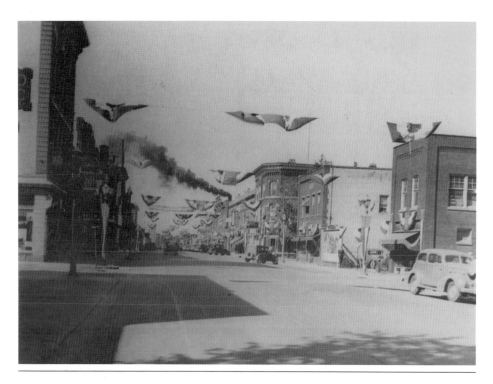

Downtown Mount Pleasant, from Broadway and Franklin Streets looking west, was festooned in 1935 for the Michigan Oil and Gas Exposition. Below, Belle's Hat Shop and the Isabella County Abstract Company (now the sole occupant) once shared the building on the former vacant lot. In the left building, Gray's Furniture, Appliance, and Television store remains, and the right building was the home of the Minute Lunch restaurant and later William J. Wood Printing before the Red Cross moved there.

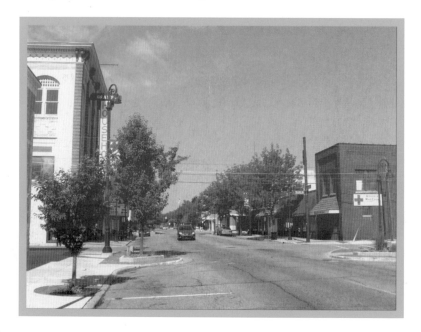

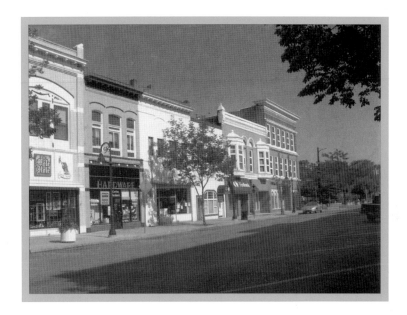

Cut Rate Hardware, Johnson's Shoes, the Blackstone Restaurant, Butts Drugs, Mount Pleasant Hardware, the Park Hotel, and the Campbell Building, below from left to right, occupy the northern part of 100 South Main Street and the southern part of 100 North Main Street in Mount Pleasant during the 1940s. The 2006 tenants of the same spaces are the Mole Hole, Curtiss Hardware, the Book Garden, Firstbank, and the Town Center, respectively.

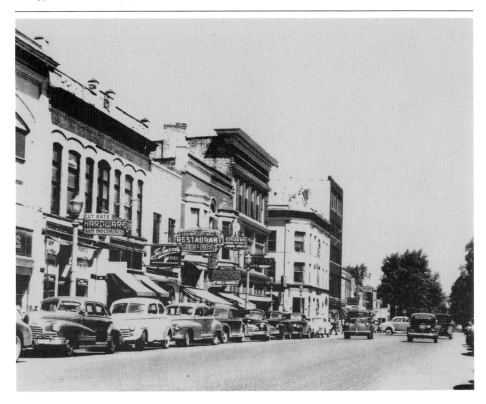

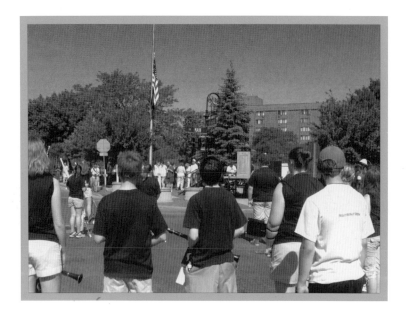

The Donovan House, below, at the northwest corner of Main and Broadway Streets, was built as the Morton House in 1860 and run by several folks until Patrick Donovan bought and built a new hotel on the site in 1891. Later named the Park Hotel (see page 38), the hostelry was a favorite among oil boomtown visitors of the 1920s and 1930s. Riverview senior citizen apartments, above, now serve as a backdrop to today's Town Center during 2006 Memorial Day ceremonies.

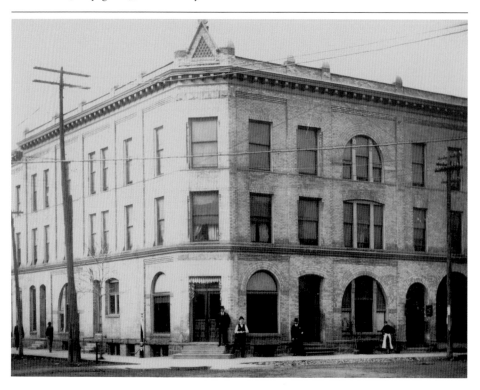

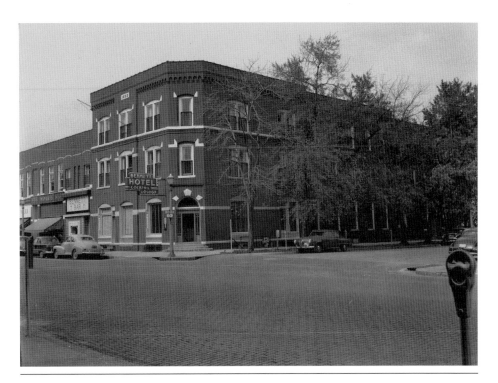

The venerable Bennett Hotel at the corner of East Broadway and Court Streets was one of two downtown hotels from 1882 until the 1950s. The adjacent Bennett Bar moved a block down Court Street when the hotel was razed and now operates as Sha-Boom, a popular university-student watering hole. The Bennett was replaced by a W. T. Grant store, open through the early 1970s, when the site became the main customer service complex for Isabella Bank and Trust, as seen below.

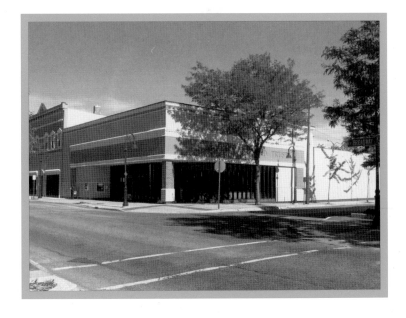

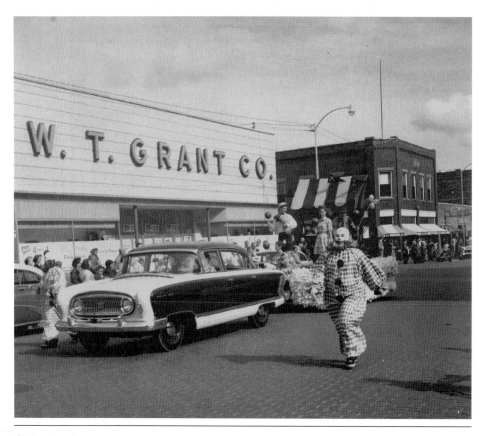

A 1950s parade marches by the W. T. Grant variety store at the corner of East Broadway and Court Streets, where across the corner to the east, at 201 East Broadway, Breidenstein's Grocery was a dominant player of the hometown-based downtown grocery market for decades. The Sun Oil Company had Michigan exploration offices upstairs in the 1930s. By 2006, the Grant location has become Isabella Bank and Trust, while the Breidenstein Building houses Norm's Flower Petal florist.

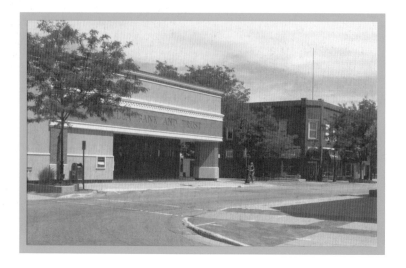

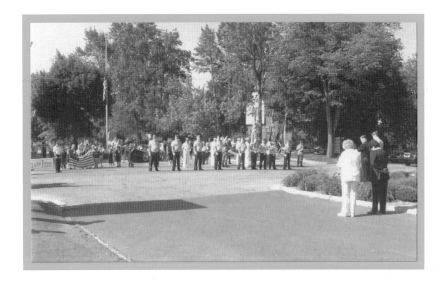

In November 1942, Veterans Day ceremonies included the dedication of the original war memorial on the south boulevard median of the Kinney Street and Broadway Street intersection, next to the Batson Chiropractic Clinic. On Memorial Day in 2006, with the original monument in the background (beside the flagpole), veterans held ceremonies at the World War II monument (seen below), the Korean War Memorial at the Town Center, Riverside Cemetery, and the new Michigan Vietnam Memorial at Island Park with the nearby Iraq monument.

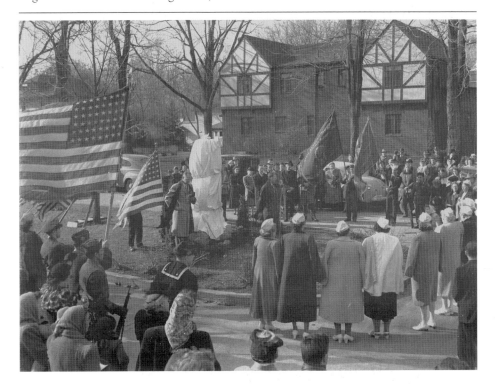

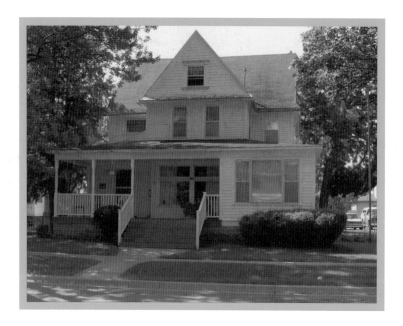

During the late 1930s, female residents of the DuHamel Apartment House, at 512 East Broadway Street, below, pose in front of the three-story white frame structure. The DuHamel House provided a safe living environment and social atmosphere close to work for lone young ladies with jobs downtown or for Central Michigan College students. In 2006, the building, now with abbreviated landscaping, remains an apartment house.

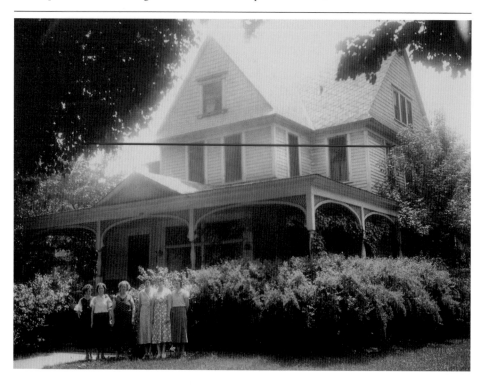

The First Baptist Church, located on the northwest corner of Broadway and Fancher Streets and pictured in the mid-1950s, was torn down after moving farther from downtown. It is now located on East High Street. The brick church hall at the right became the International Order of Oddfellows Lodge 217, and the site of the wooden church now serves as a parking lot for the hall and Dorothy's Hair Design, a business on the ground floor.

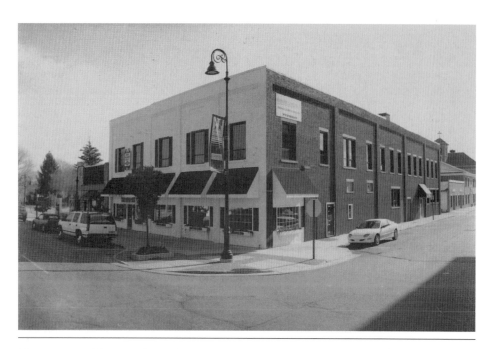

The Hersee Building, at the southeast corner of Broadway and Franklin Streets, above, was built in 1921, its upstairs offices serving as home to a number of oil exploration ventures and most recently Coldwell Banker Mount Pleasant Realty. A March 5, 2004, fire gutted the structure. Sacred Heart Academy Catholic school appears in the right background. Rebuilt and reopened in 2005 by Mount Pleasant Realty, with modern office suites housing varied enterprises upstairs, the site remains a viable business center.

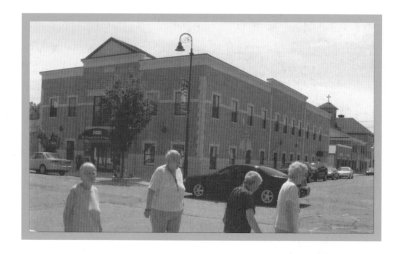

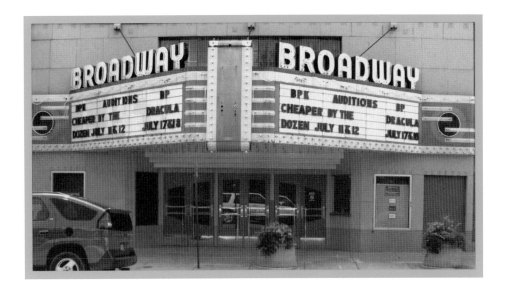

The Vaudette Theatre, on East Broadway Street, was built about 1906 by Charles "Tip" Carnahan to show silent movies and stage acts. When Carnahan sold the theater to Bert Ward in 1915 and started the General Insurance Agency, the theater moved just a few storefronts east, and the name was changed to the Broadway Theater. Bert's son Lee owned and managed both the Broadway and later the Ward (see page 45) until both were purchased by the Loeks Theater chain in the 1980s. In 2006, the Broadway is home to a community players group that performs regularly.

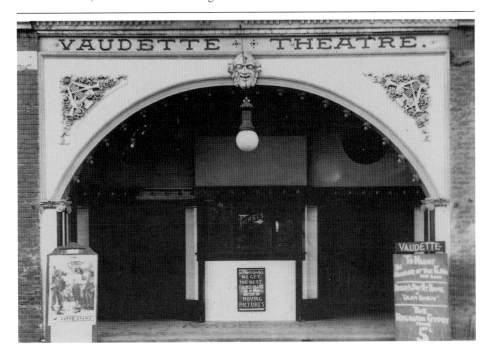

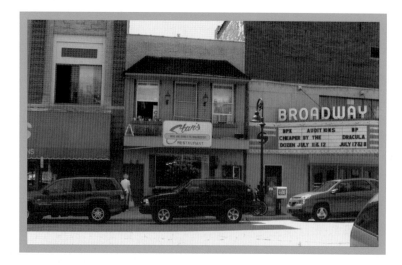

Next to the Broadway Theater in the early 1930s, the Sno-White Bakery, below, was a popular downtown gathering place. Note the theater had begun sporting a marquee, and young Robert Taylor was thrilling audiences in the movie *Private Number.* Through several name and ownership changes, the bakery location, now Stan's Famous Restaurant, is still the site of the morning coffee forum, where issues big and small are vociferously addressed daily.

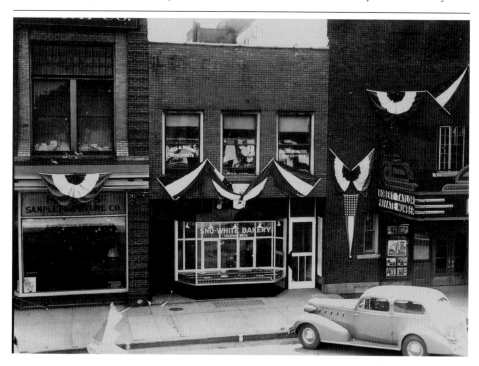

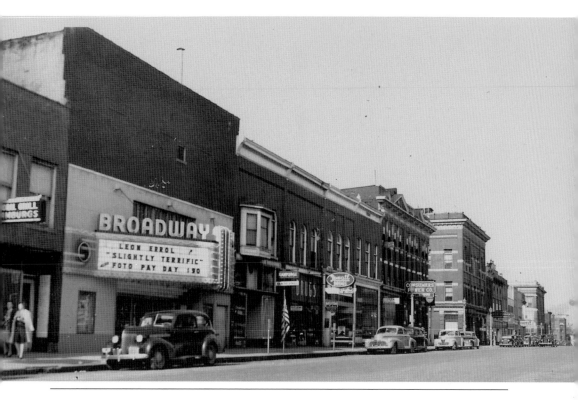

The south side of 1940s East Broadway Street includes the Central Inn and a neon-lit marquee version of the movie house. Farther along the street are Broadway Bar, Rexall Drug Store, the state liquor store, a popular bar-poolroom-restaurant called Metropole, Consumers Power Company, Western Union, and the Isabella Bank and Trust, with the Commerce Building anchoring the 100 block. In 2006, below, Stan's and the Broadway Theater share the block with Headliners Beauty Parlor and the Isabella Bank and Trust offices.

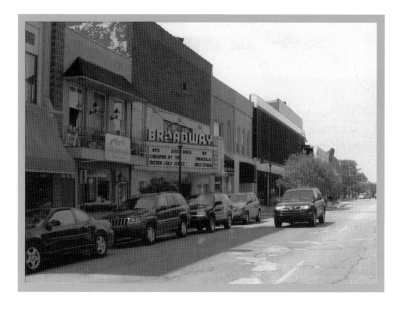

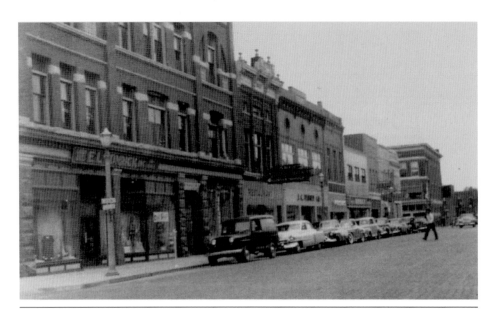

In the 1950s, East Broadway Street's 100 block boasts E. L. Conrick Clothing, Olympia Restaurant, J. C. Penney Company, Voisin's Jewelry, Clabuesch Drug, Thompson's Jewelry, and Exchange Savings Bank. In 2006, the block offers Ace of Diamonds Jewelry, the Stone Soup gift shop (Simply Weddings downstairs) in a building that was once a bank and still includes a vault, the Mount Pleasant Area Chamber of Commerce and Mount Pleasant Convention and Visitors Bureau, Simply Engraving, the Basket Tree, Nail Art, Total Eclipse Design, and the National City Bank.

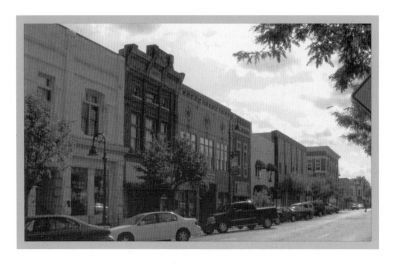

The north side of Broadway Street, where College (now University) Street forms a T, below, was the annual site of the community Christmas tree for many decades, offering a holiday-lit beacon visible from three directions from the front of the Economy 5-and-10-cent store, the General Insurance Agency (upstairs), and Dittmann Shoes. In 2006, Max and Emily's Eatery, the Vision Studio of the Performing Arts (a dance studio), the west edge of Isabella Bank and Trust, and many more trees adorn the site year-round.

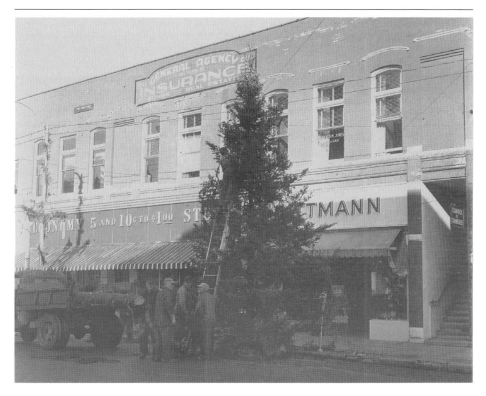

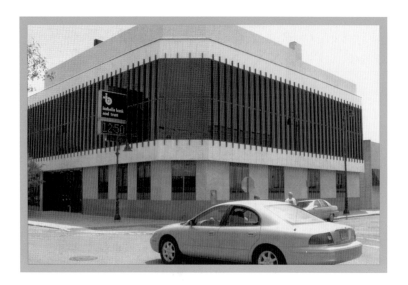

At the southeast corner of Broadway and University Streets, First National Bank served the banking public from the early 1880s until 1903, when Webber and Reid's private bank was purchased by John S. Weidman. The Isabella County State Bank was chartered by the state as a financial institution in July 1903. Adding the landmark clock (now a time and temperature device) to the Broadway Street facade, Isabella Bank and Trust has called the corner home for more than a century.

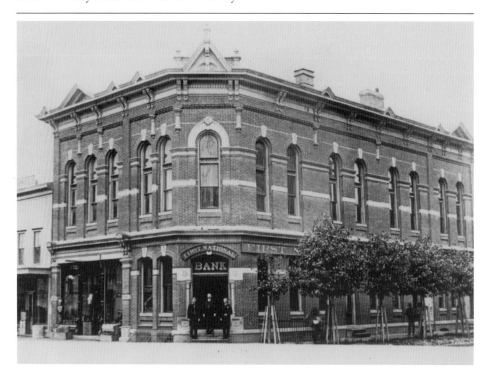

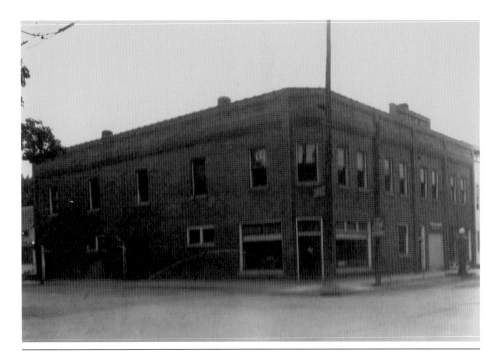

On the southwest corner of Michigan and University Streets, the structure commonly known as the Johnson Building housed Johnson's Garage, a Ford car dealership in the 1920s, then an Allis-Chalmers tractor and farm implement dealership and Studebaker automobile dealership before being razed in 1963. Its demolition made room for the three-window drive-up branch of Isabella Bank and Trust. The first new downtown construction since the W. T. Grant store in 1955, it is one of the institution's many central Michigan branches.

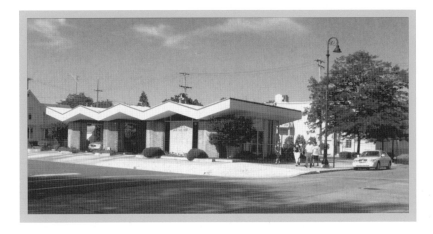

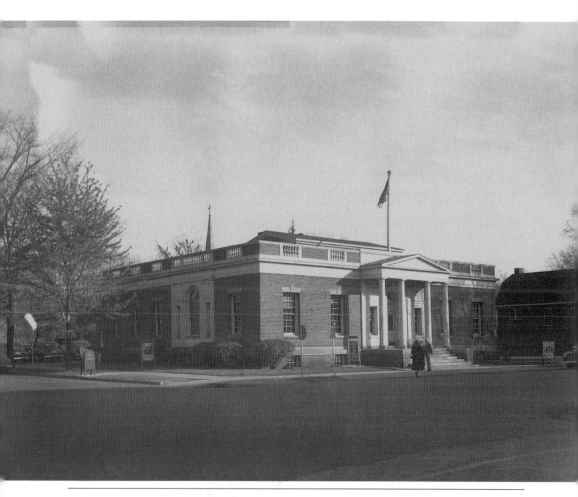

The United States post office at Mount Pleasant was located at University and Michigan Streets from 1920 until the late 1960s, when it moved to the 200 block of East Illinois Street. In 2003, the post office moved to the north end of Main Street at Pickard Street. The University and Michigan building housed offices for Mount Pleasant Public Schools until the late 1990s and is vacant, pending remodeling by a private developer.

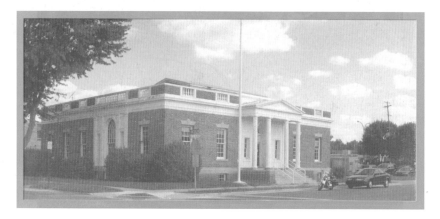

The Mount Pleasant Municipal Building stood at 120 South University (known earlier as Normal, then College) Street in the 1950s. Finished in the 1950s on a parking lot that was formally a church site, the structure, housing city offices and the fire department, was vacated by 1987, when city offices moved to 401 North Main Street (see page 68). From 1925 until 1950, the fire department was located in the 200 block of South Main Street (opposite the Ward Theater, page 45). The building now serves as offices for a diverse number of firms, including the Mid-Michigan Engineering and Survey Company.

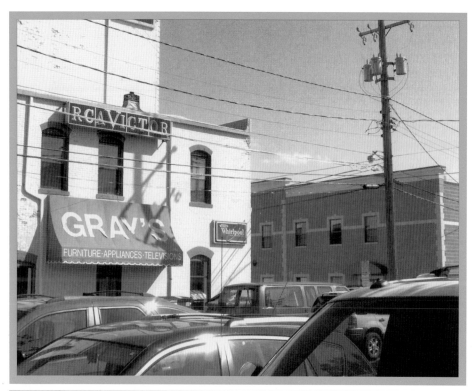

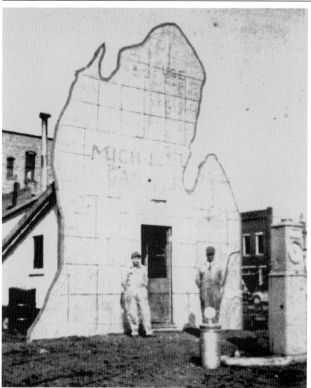

To the left, Hood Holenbeck and Fred Schafly (right) pose in front of their Michigan Gas filling station in the 1920s. The scene's location was determined from the building's visible parts. Above, the same locale, behind Gray's Furniture, Appliance, and Television store (page 14) and the Hersee Building (page 22), makes for probably the least picturesque "now" scene in this book.

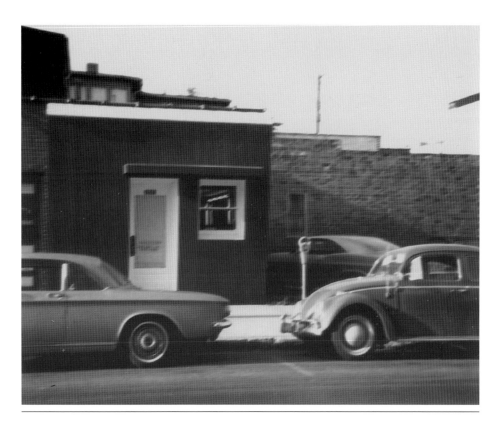

Bob's Barber Shop, founded by Bob Cook in the 200 block of East Michigan Street, was scarcely wider than the length of the compact Chevrolet Corvair or Volkswagen Beetle parked in front in 1967. In 2006, just across the parking lot, Bill Cook continues the family barbering tradition begun by his father in a spacious three-chair freestanding establishment. The backs of the Broadway Theater and Gray's Furniture, Appliance, and Television tower in the background.

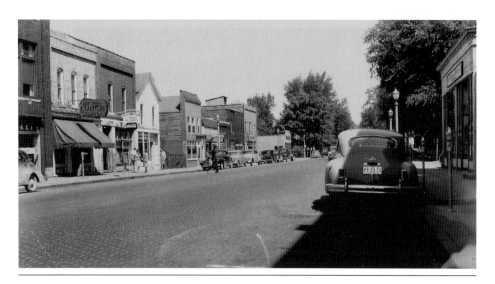

In 1948, the west side of the 100 block of North Main Street is crowded by the Eat Well Restaurant, Main Billiards, and other bars, anchored on the north end by the upstairs Elks Club and the then-new A&P grocery store (center) on the far left. In the 2006 scene below, that side of the street (left) has only one building, housing Boge, Wybenga and Bradley CPAs, with the rest given over to the Town Center and River of Time bronze sculpture parks and bisected by Mosher Street. The Daily Grind Coffee Shop and Pisanello's Pizza are at the right.

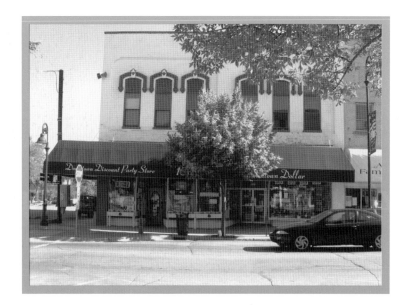

The northeast corner of Main and Broadway Streets was occupied through the 1950s by a five-and-dime store before Lloyd Marzke opened his upscale Lloyd's Footware shoe store. Following Marzke's death, the building became the Downtown Discount Party Store in the west half and was joined by a sister establishment, Downtown Dollar, in 2006. Next door was the Downtown Restaurant (originally the Spoon and Straw), so named since 1932 before the 2006 change to Larrabees.

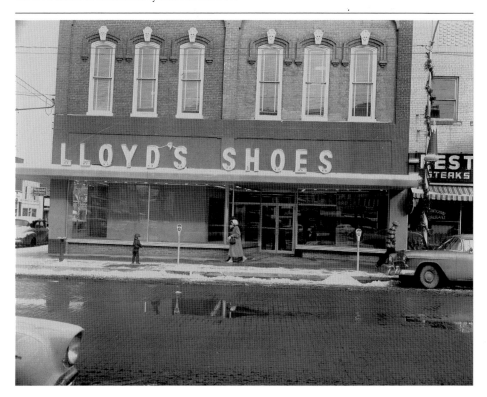

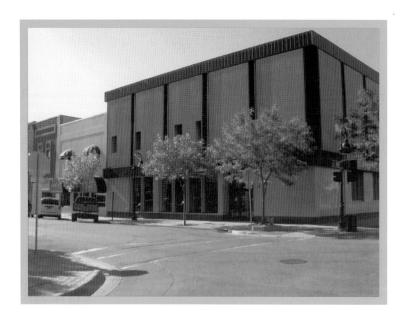

Established by G. A. Dusenbury and Company in 1881 as a private establishment, the Exchange Savings Bank was incorporated as a state bank in May 1884 in the dormered windows on South Main Street (facing page). Offices on the southeast corner of Main and Broadway Streets were built in 1907 and evolved architecturally to anchor the corner with a sandstone edifice in 1955, seen below. Beginning in the 1970s, the bank changed hands a couple of times and is now the National City Bank's primary Mount Pleasant office.

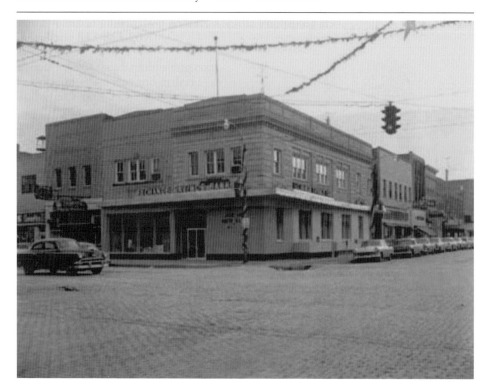

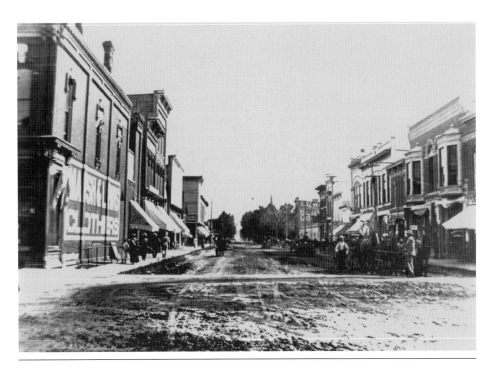

Looking south at the 100 block of South Main Street in the early 1880s, this view shows Marshal Clothiers at the near left corner, which became the site of the Exchange Savings Bank in 1907. On the right, rooflines remain largely unchanged, and the two dormered windows on the second building from the left continue to be a dominant feature of the block. A closer look at the west side of the street in later years can be seen on pages 15 and 39.

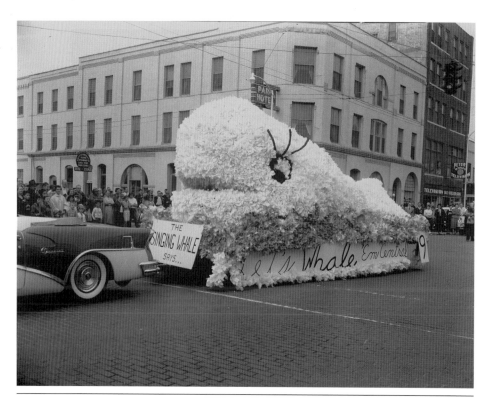

The Park Hotel, located on the northwest corner of Main and Broadway Streets and pictured above, was often the background for parade photographs. The Campbell Building, right, was the site of Mount Pleasant's first television sales and service store, opened by Coleman Peters in the late 1940s. In 2006, the hotel has been replaced by Town Center park, a paved and landscaped venue for a Saturday farmers' market in summer, the community Christmas tree, the Korean War Memorial, and other community events.

The northwest corner of Main and Michigan Streets offers the opposite perspective of the scene of the west side of the 100 block of South Main Street (see page 37). The near two storefronts would become Dondero's (later Wakefield's) and Spagnuolo's (later Bill's) grocery stores in the 1920s through the early 1970s, evolving through a number of retail establishments to become the Brass Café and Saloon restaurant of the present. From this viewpoint, trees obscure any hope of a look at the buildings on the opposite side of the street.

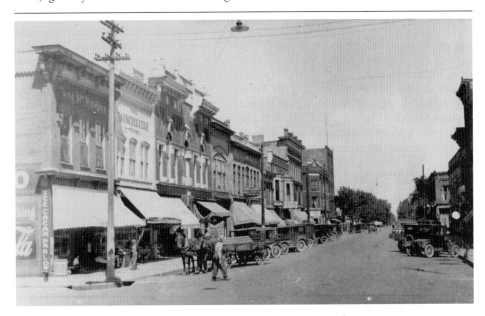

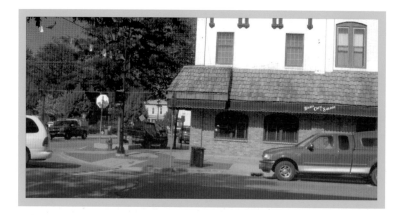

A look down West Michigan Street from the southeast corner of Michigan and Main Streets in 1988 shows the opposite corner occupied by Off Broadway, a clothing store, with the Brass Saloon (now Brass Café and Saloon) in the Spagnuolo building on the right. Down Michigan Street, one can see the former Kinney Wholesale building, now a parking lot, and a residence that still exists in the 2006 scene.

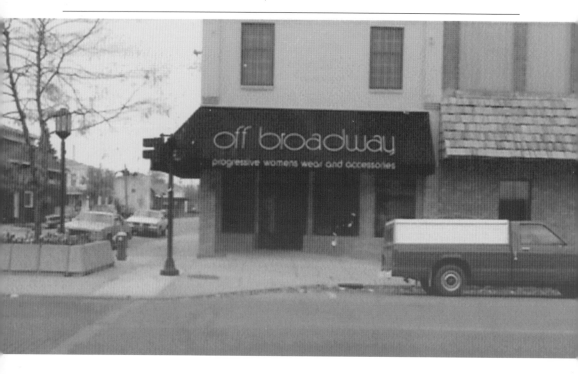

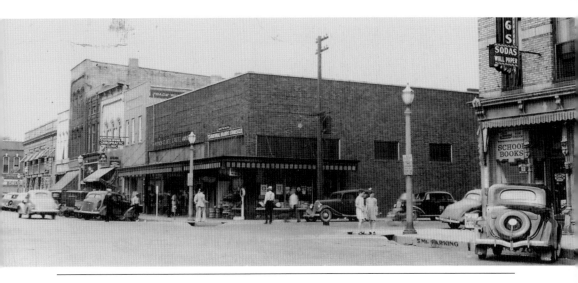

This early-1940s view of the east side of Main from Michigan Street shows Mount Pleasant Drug Store on the right, with the Atlantic and Pacific grocery store and Munn Pure Food (Glen Oren's Department Store was in the basement, destined to take over the building in later years) on the opposite corner. Up the street was the New Yorker children's clothing store. Below, the same scene in 2006 finds only the New Yorker still in business at the same location.

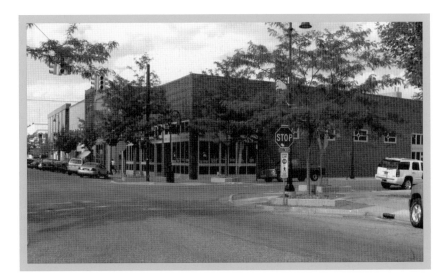

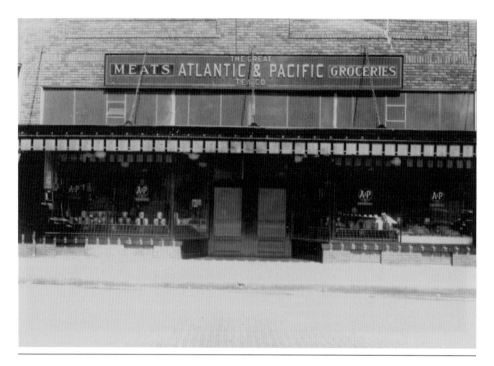

"Shop downtown" was more than a slogan, it was just about the only game in town during the 1920s, when the east side of the 100 block of South Main Street included Atlantic and Pacific grocers (later known as just A&P) on the northeast corner of Main and Michigan Streets, with Kroger just a few doors away. The corner building was later occupied by Oren's Department Store and is now home to the Main Street Professional Center.

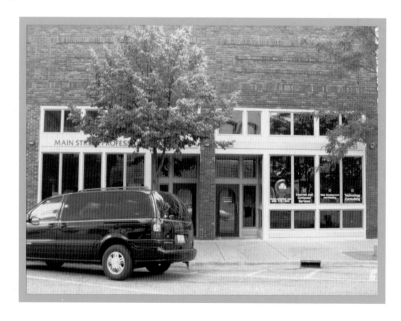

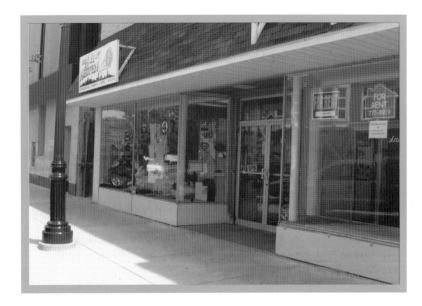

The Kroger grocery store's first Mount Pleasant location was at 103 South Main Street until the early 1950s, when it became the initial location of the now-defunct Giant Super Market chain, then Murphy's 5-and-10-cent store and a parade of other businesses. The building was distinguished by a second-floor bowling alley until the early 1960s. Half of the storefront is now occupied by Hall of Heroes, a sports card shop.

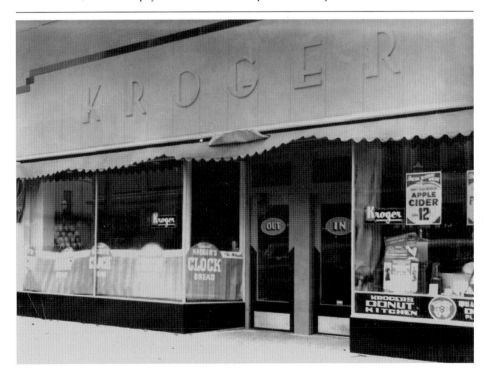

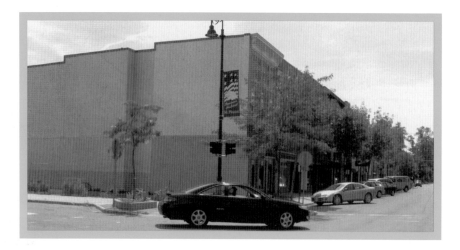

In this early-1950s view of the east side of South Main Street's 200 block, Smith's Drug Store appears on the near corner. Down the block is Household Appliance. The far end reveals Model Bakery, Kirkey Electric, the Flamingo Bar, Frank's Grocery, and Leo Beard's Lincoln-Mercury-Continental dealership. By 2006, the Smith building has been destroyed by fire and reclaimed as a flower garden, Kirkey's is now Steiner's Pizza World, and the Flamingo is the Bird, a favorite nightspot for young people.

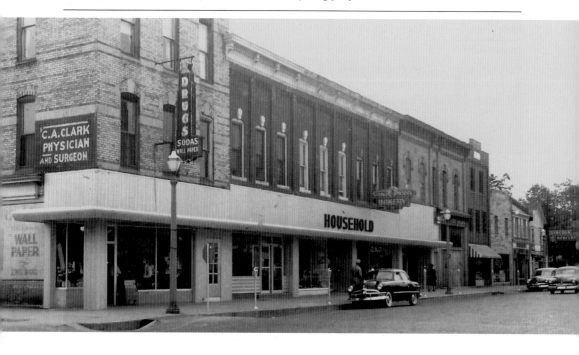

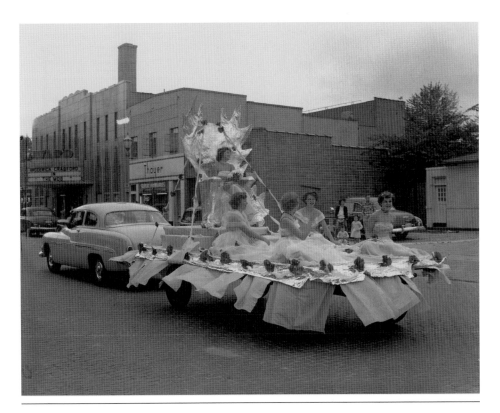

A 1950s parade photograph shows the Ward Theater on the west side of South Main Street and in the center of the 300 block. Lee Ward and his son Kent owned the Ward Theater until selling to the Loeks group, which eventually closed it when it built a multiscreen theater south of town. The Thayer Dairy soda fountain later became Jack's Snack Bar, and a plethora of other businesses followed. The buildings are now the property of the Young Church.

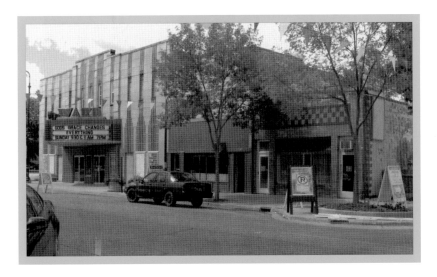

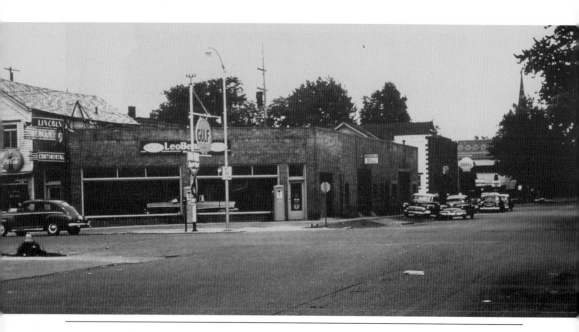

Leo Beard's Lincoln-Mercury-Continental dealership dominated the northeast corner of Main and Illinois Streets in 1955. Down the street, an office building and a Shell gasoline filling station, right, are now gone, replaced by a municipal parking lot. At the far right is Sacred Heart Catholic Church, which was vacated for the new church built two blocks away (see page 92), struck by lightning, and razed to make room for the Sacred Heart Academy gymnasium in the 1990s. The Beard building now houses the Listening Ear phone counseling service.

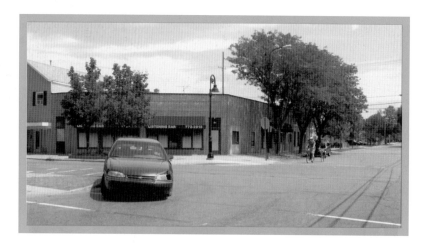

CHAPTER 2

OUT ON
MISSION STREET

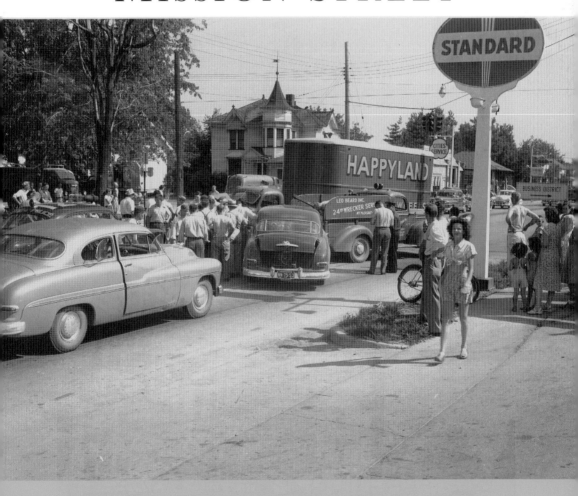

A 1950s-era traffic mishap drew a crowd to Mission and Broadway Streets, where U.S. Highway 27 was so seldom traveled that folks could cluster in the northbound lane. Until August 2006, Sweet Onion had occupied the corner to the immediate left for 34 years. The Muffler Man is now on the southeast corner, and Rite-Aid Pharmacy is located just out of the frame to the right.

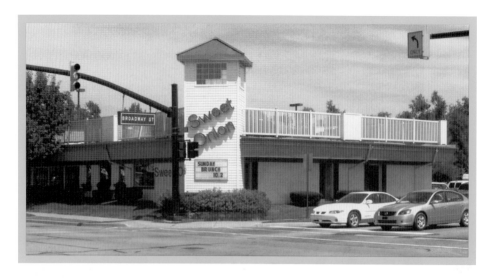

In the late 1950s, at the beginning of the Mission Street expansion explosion, Chris Moutsatson, owner of the Olympia Restaurant (see page 26), closed that establishment to open Chris's Drive-In on the northeast corner of Broadway and Mission Streets. In 1972, the LaBelle Group of Mount Pleasant opened the Sweet Onion Restaurant at that location, founding a chain of three restaurants that had all closed by mid-2006. The photograph above is among the last taken of the Sweet Onion.

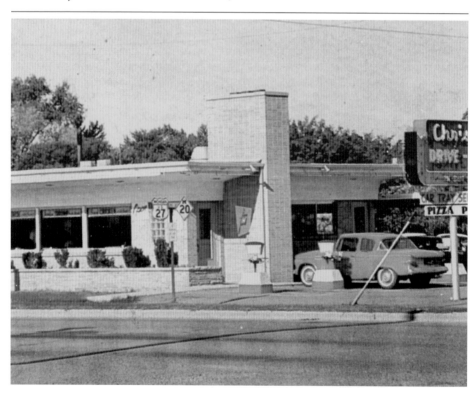

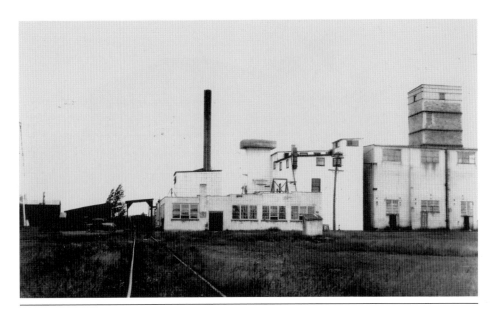

North of town in the early 1900s, the Dow Chemical Company sunk brine wells, opening a satellite to supplement its Midland home operations. The company pioneered acidizing as an oil well completion technique in the Mount Pleasant oil field in 1931, founding Dowell, Inc. Following Mount Pleasant's growth as "Oil Capital of Michigan," the company turned the site into a Dowell operation, sharing property with the Lee Equipment Company. Pioneer Oil Tool, an oil field equipment company, is the site's most recent occupant.

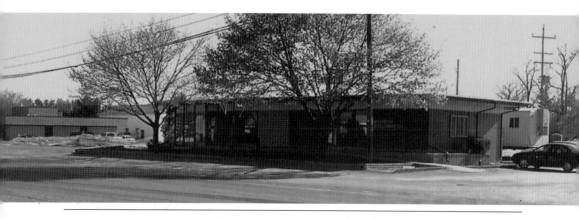

The Mount Pleasant Lumber Company vacated its West Broadway Street location in the late 1940s to move to quarters on Mission Street at the northern city limits. The lumber company moved in the 1970s, and the site was refurbished as offices for oil and gas exploration and production-related companies, principally the Muskegon Development Company, H. E. Tope, Maness Petroleum, and William J. Strickler geological consultants. In 2005, the building was torn down to make room for the firms' new office building, seen below.

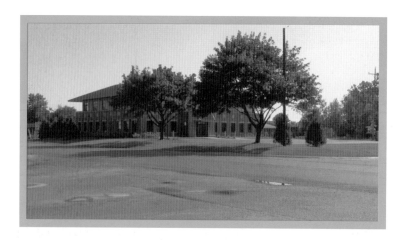

OK Tire and Wheel Alignment opened just north of the state police post along the two-lane U.S. Highway 27 (North Mission Street) in the early 1950s. Upon being vacated by that firm in the 1960s, the building became the Enterprise Printing Company, then the original Wendel's Furniture until that store moved to a large emporium on Mission at Pickard Street. The structure has returned to its automotive roots as Southwest Brake alongside the now five-lane thoroughfare.

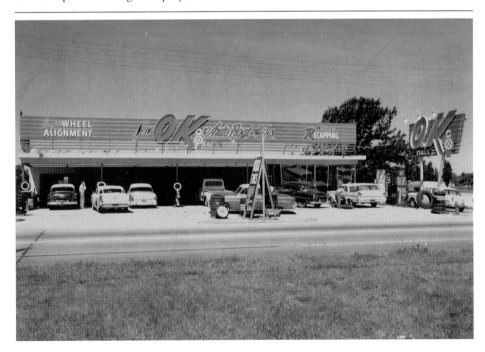

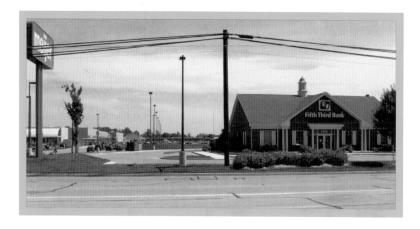

Frank Lovejoy (center) opened the Oil Well Cementing and Acid Corporation on North Mission Street in 1936. The site later housed the Union Rotary drilling contractor's shop, and still later the North American Drilling Company. The business was located where the Mount Pleasant Meijer Department Store's North Mission Street northernmost entrance drive is flanked by a Fifth Third Bank branch office.

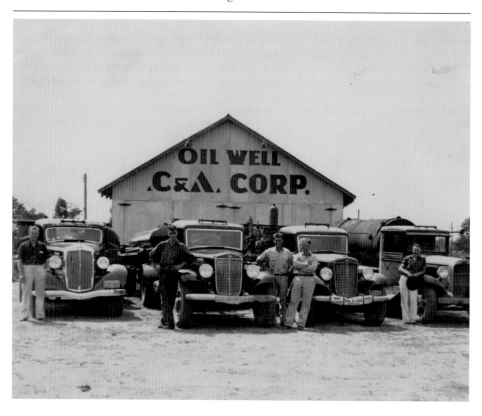

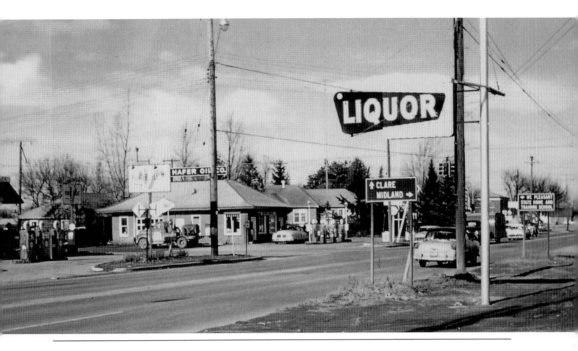

Roy D. Hafer built a home and opened a filling station in 1927, operating at the corner of Mission and Pickard Streets until the late 1950s. The property was sold, with house and service station demolished in 1981 for construction of the Flap Jack Shack (now J. W. Fillmore's) restaurant. The Liquor sign above refers to the Green Spot Bar, a longtime, and still, local favorite. Below, Mount Pleasant High School cheerleaders hold a July 2006 car wash at the corner.

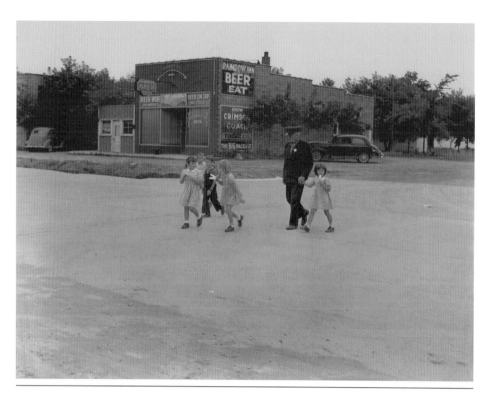

The southwest corner of Mission and Bennett Streets, above, finds a 1930s uniformed policeman guiding children from Kinney Elementary School across the two-lane U.S. Highway 27, near the Rainbow Bar. Below, in 2006, the Good Stuff used furniture shop has replaced the Rainbow Bar, and Main Street Video continues to keep the corner busy. Kinney Elementary School is now used for other purposes, and the age of busing has ruled out guarded escort across the now five-lane traffic artery.

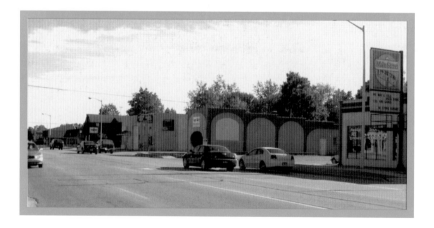

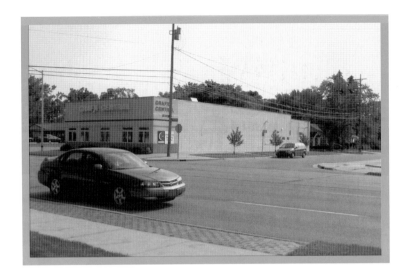

Gould Rexall Drugs moved into the Fortino Building at the northeast corner of Mission and Crosslanes Streets in the early 1950s, operating there until moving to the larger Giant Super Market building in the 1970s. The business was later sold to the Perry drugstore chain and closed in the 1980s. The original Gould location was a Four Seasons window store before becoming Grafx Central, a commercial printer, in the 1990s.

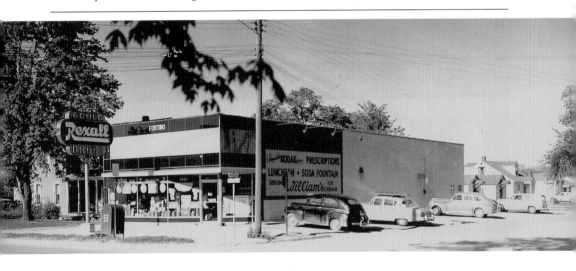

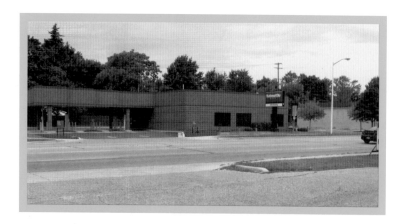

In the early 1950s, as a nod to the increasingly mobile nature of its clientele, the Exchange Savings Bank opened the first drive-up branch banking establishment in Mount Pleasant on the southwest corner of Mission Street at Crosslanes Street, calling it an "auto bank." More than half a century later, the pioneering drive-up banking venue now operates for Exchange Savings Bank's latest business heir, National City Bank.

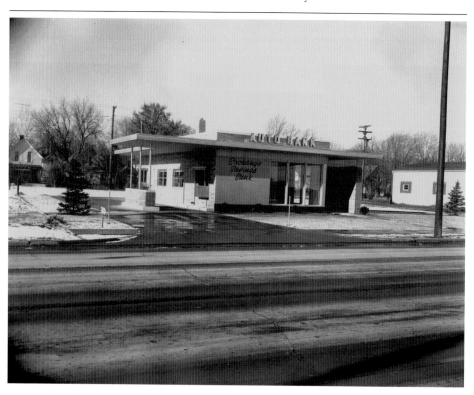

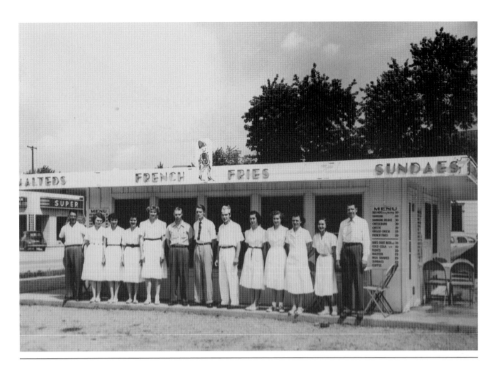

The original Pixie Drive-In restaurant opened in 1948 at the Chippewa and Mission Streets corner of Turner-Labelle's used car dealership. From there emerged today's LaBelle Management, the owner/operator of restaurants and hotels statewide. Giant Super Market stands across the street to the left in a space later occupied by Gould Drugs, Perry Drugs, and now Family Video. When closed for the winter, the original Pixie became the Christmas tree lot for Mount Pleasant High School student fund-raisers for senior trips.

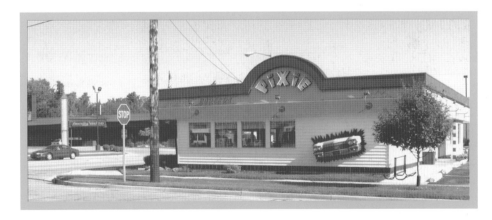

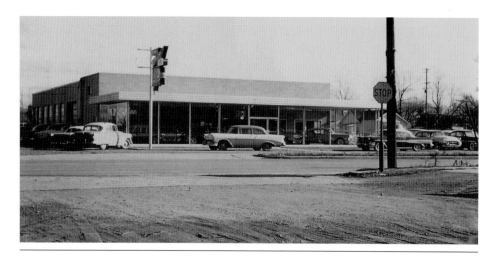

In 1963, Mount Pleasant oilman Earl G. Hartman Sr. purchased Naumes Motor Sales, begun in the 1950s, and opened Hartman Motor Sales at the T formed by the east end of unpaved Mosher Street, near where Mission Street (U.S. Highway 27) meets Broadway Street. Pontiacs, Cadillacs, Buicks, and GMC trucks have been sold at the location ever since. No longer at the end of an unpaved street, the dealership, now known as Dean Burger's, has expanded along with the Mission Street commercial corridor.

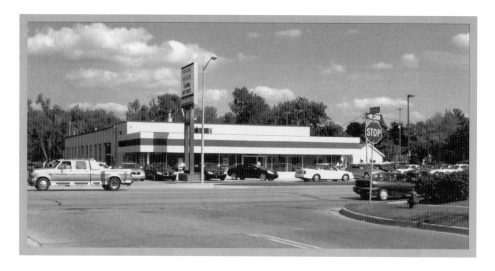

In this northward view taken in 1956, residences still dot Mission Street where it encounters Illinois Street. The Geroux Motors used car dealership then wrapped around the Tastee Freeze on the corner. Tastee Freeze was a seasonal soft-serve ice-cream establishment owned successively by several families to offer their children an opportunity to earn college money. The business closed in the mid-1980s, to be swallowed up by the parking lot for the Isabella Community Credit Union.

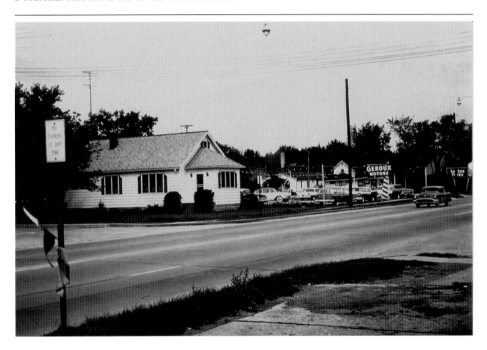

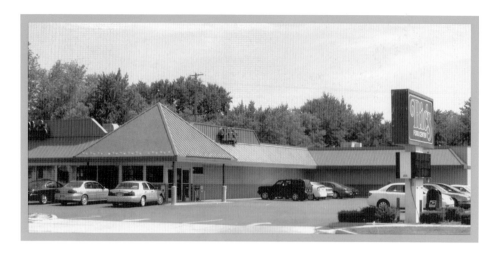

Vic Erler established Vic's Shop-Rite Super Market at 705 South Mission Street, near the High Street intersection, in the late 1950s on the site of the 1939-established Lucky's Market. The market stood where U.S. Highway 27 met Michigan Route M-20 with an Erler-owned pharmacy building immediately at that intersection. In 2006, Vic's is now Ric's, and the pharmacy site is part of the parking lot for Ric's Food Center.

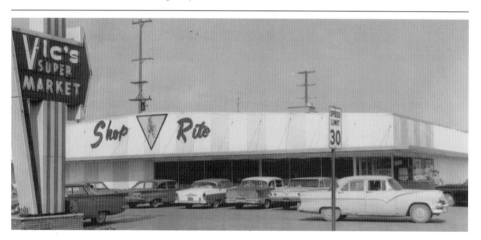

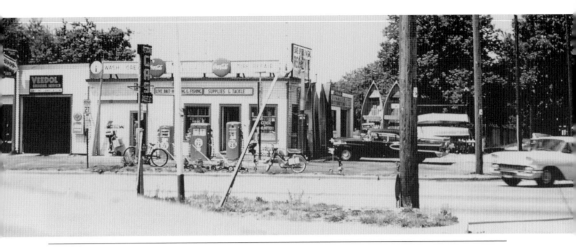

Located at the southwest corner of Mission and High Streets, Pete Miller's sold gasoline, automotive services, sporting goods, bait, sundry supplies, and even automobiles into the 1970s. A rarity in the 1950s, Miller's was open 24 hours during deer and trout seasons to accommodate sportsmen northbound on U.S. Highway 27. After occupation for many years by Tony's Sandwich Shop, the building now serves as offices for the Premier Insurance Agency. Below, Fancher Elementary School can be seen at the right.

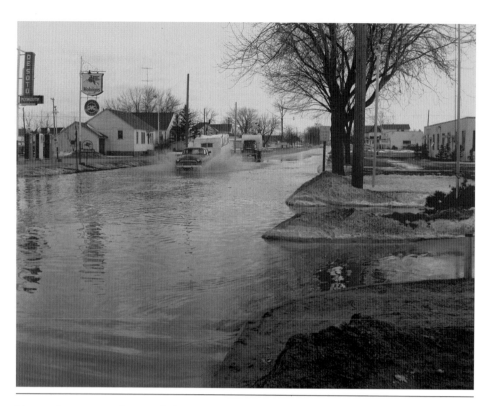

Mission Street, a two-lane road also known as U.S. Highway 27, was prone to flooding well into the 1960s. The view above was taken in the early 1950s, looking south from the 800 block of South Mission. The highway was rerouted to an expressway, the U.S. Route 127 freeway, in the 1960s, but the Mission Street of today is a five-lane thoroughfare of nearly three miles of retail activity connecting the major shopping complexes of the north and south.

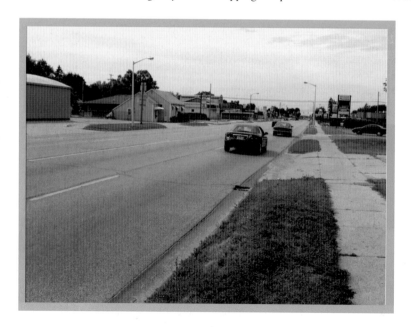

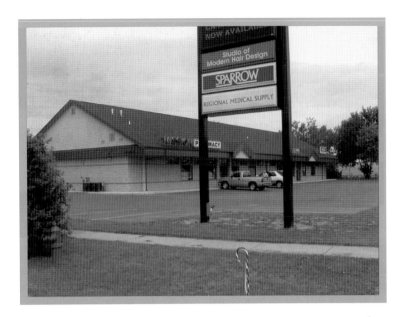

On the southwest corner of Mission and Gaylord Streets, below, the 1930s Mount Pleasant School System built a central kitchen to service city schools. Later used as a vocational training auto repair shop by the school system until the 1970s, the building stood vacant for many years and was finally torn down. In 2005, it was replaced by the structure above, currently housing Mission Pharmacy, Sparrow Regional Medical Supply, and the Studio of Modern Hair Design.

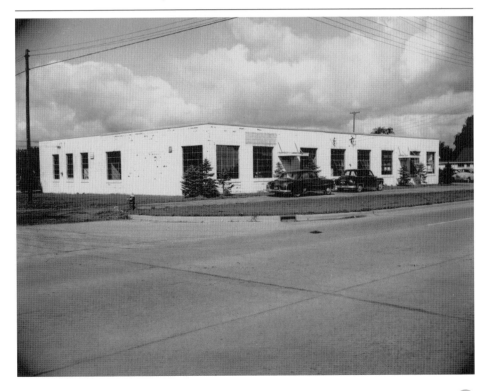

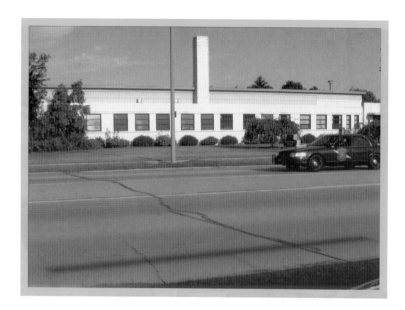

The Michigan State Highway Department building was constructed along the narrow dirt road south of Mount Pleasant in the 1100 block of South Mission Street, adjacent to the campus of Central Michigan College, as seen below. The site is home to the Central Michigan University campus offices of the Michigan Special Olympics, alongside the five-lane major traffic artery that is Mission Street, in 2006.

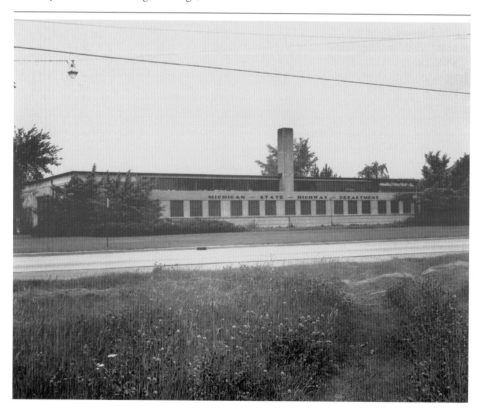

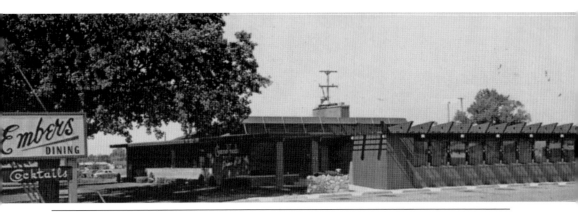

In 1957, Detroit native and Central Michigan University graduate Clarence Tuma with Norman LaBelle (see page 57) opened the Embers Restaurant where Preston Street intersects with South Mission in what was then considered rural Mount Pleasant. The Embers quickly became known as home of "the Original One-Pound Pork Chop." In 1967, Tuma became sole owner of the restaurant, now under the management of his son Jeff, who continues the famous Embers tradition of offering fine dining experiences in the face of mounting competition.

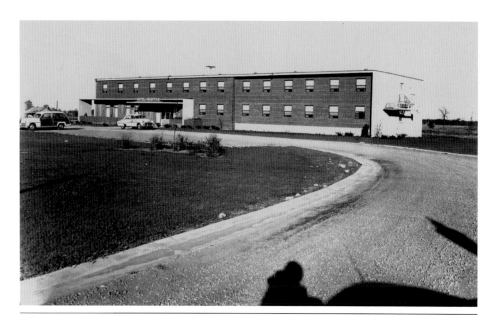

Faced with the loss of both downtown hotels (the Park and the Bennett) in the late 1940s, the people of Mount Pleasant raised funds and constructed a state-of-the-art motor hotel named the Chieftain (after a contest to name the venture) at 1523 South Mission Street in 1951. Now the city has 10 hotels, and the Budget Inn is slightly past the center of the city's booming business corridor, slated for destruction to make room for a Mexican restaurant (to be Mount Pleasant's fourth) during 2006.

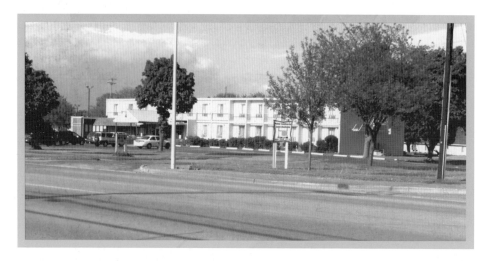

CHAPTER 3

AT THE WORKPLACE

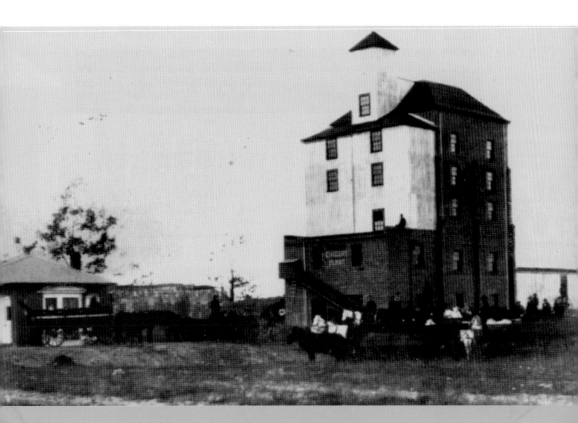

Chicory is used as a homeopathic medicine and as a coffee augmentation/substitute. It was cultivated on a large scale in Michigan and processed in Mount Pleasant from late in the second decade of the 20th century until the 1930s at this plant near where North University Street ends at Pickard Street.

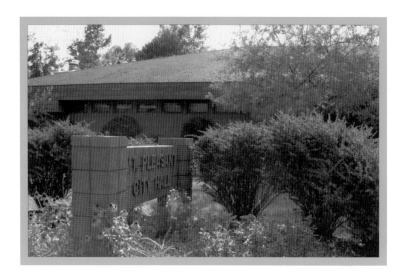

The Horning Elevator conducted business at the northwest corner of North Main and Lincoln Streets until 1903, when the space became Chatterton and Sons, a firm involved in bean packing and shipping that employed about 35 local girls. In 1934, the location saw the opening of Atha Supply, an oil field supplier, in the first air-conditioned building in Mount Pleasant. Atha was later bought by Oilwell Supply and operated until the building was razed in 1986 to allow room for construction of city government offices.

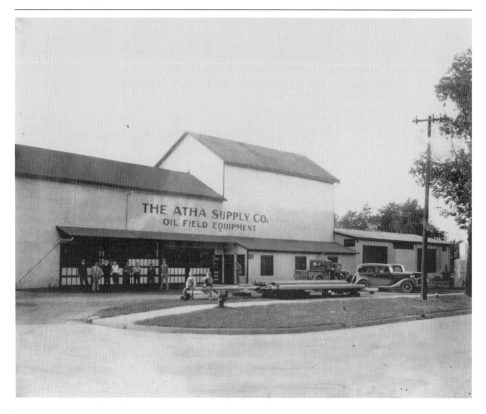

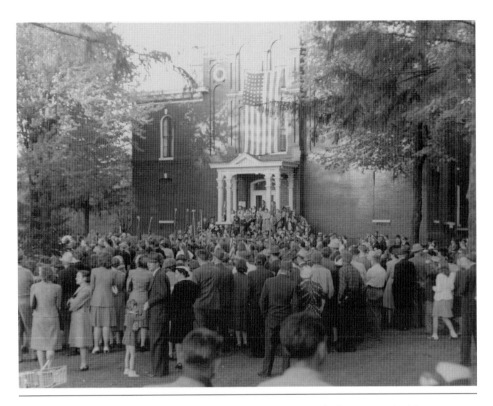

The lawn of the Isabella County Courthouse, in the 200 block of North Main Street, is crowded on an August afternoon in 1945 as hoards of residents swarm there to verify that World War II had indeed ended. In modern times, the Isabella County building occupies the entire block, and communications advances have supplanted the "go to the courthouse to get the news" phenomenon.

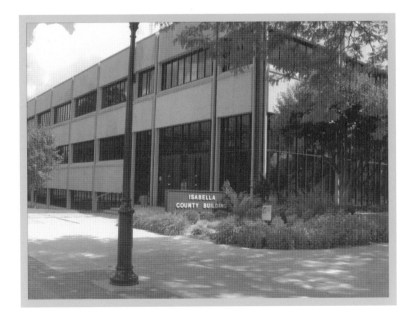

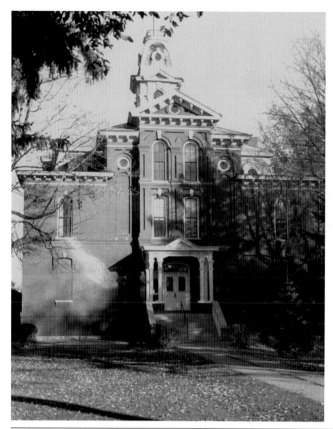

Completed in 1877, the Isabella County Courthouse served as county offices, with stately trees offering shade for loungers on the large open grounds, until budgetary concerns caused its end in 1972. Now Mosher Street slices through the grounds on the south side of the county building, right, and another block of the tree-lined street on the north side was sacrificed to make room for the Isabella County Trial Court building, left.

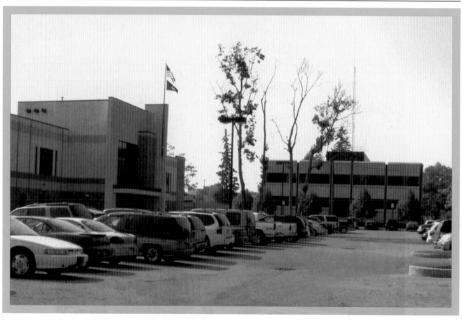

AT THE WORKPLACE

William Carrol, center, his unidentified son, left, and Sheriff Palmer Landon stand in front of the Isabella County Jail, built of slab wood on the northwest corner of what are now Court and Mosher Streets in 1870. Courthouse construction began two years later. After 80 years of being housed in an ornate Victorian-style structure, the Isabella County Sheriff's Department and Jail moved to its present location in 1962.

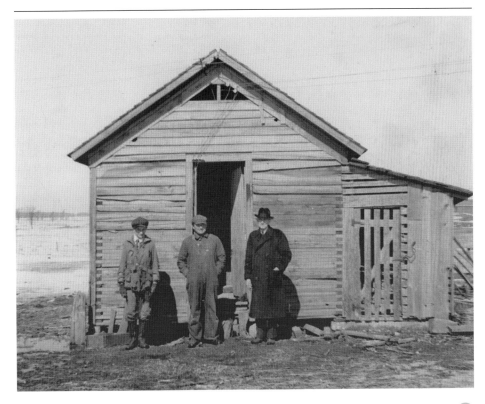

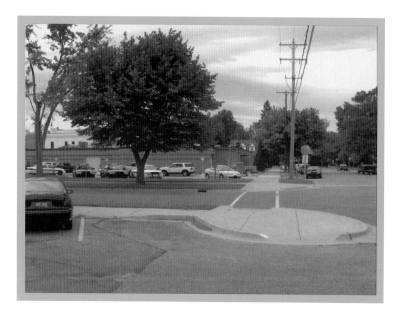

The Isabella County Sheriff's Department and Jail, below, was built in the 1880s on Court Street behind the Isabella County Courthouse. The building housed the sheriff's family in an upstairs apartment. The sheriff's wife oversaw preparation of prisoners' meals. Above, some of the courthouse grounds are now lost to the 1960s extension of Mosher Street, the present Isabella County Sheriff's Department and Jail no longer includes the sheriff's living quarters, and meal preparation is in different hands.

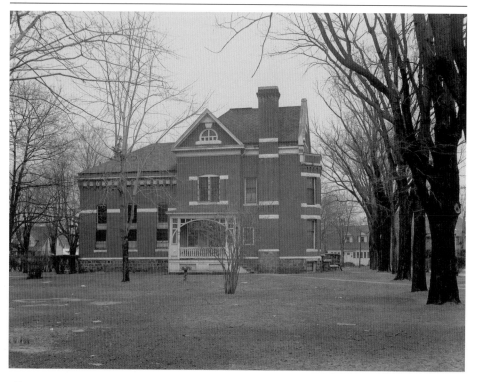

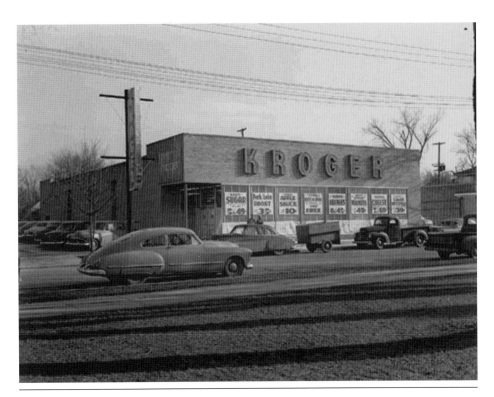

The building at 210 Court Street, across from the Isabella County Sheriff's Department and Jail, was constructed in the 1950s to accommodate the Kroger store move from the 100 block of South Main Street (see page 43). The Kroger store has moved three times more and, in 2006, is located at the farthest southern reaches of the southern Mission Street shopping corridor. The 210 Court Street site, a Sears store for a time, now serves as offices for a diverse group of firms, including Lapham Associates Engineering.

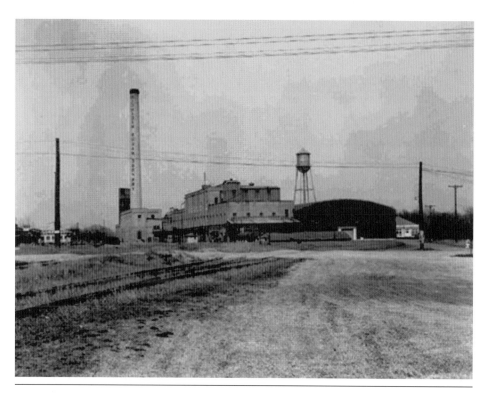

A 1903 attempt to build and equip a sugar beet–processing plant on Pickard Street, near the Main Street T, failed. H. E. Chatterton and W. D. Hood bought the plant in 1919, and the Columbia Sugar Company brought it into operation in 1920. Diminishing crops and price fluctuations bankrupted Columbia in 1931, and four owners later, the plant closed in 1947. The location lay fallow until the Chippewa Beverage Company revitalized it in the 1960s.

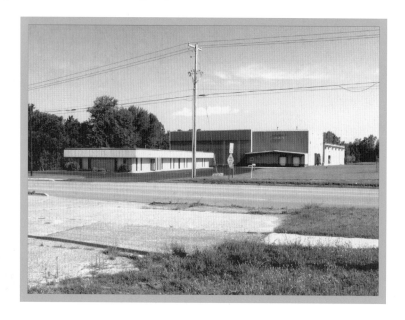

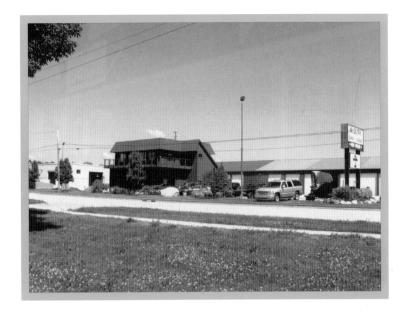

The Roosevelt Refinery is undergoing an update and expansion following a 1948 fire in this 1950 view, below, taken from the forest line across Pickard Street in the 600 block. Built in the aftermath of the 1928 Mount Pleasant oil field discovery, the facility became the Leonard Refinery in the 1950s, then the Total-Leonard Refinery in the 1960s, and was phased out in the early 1970s. McGuirk Sand and Gravel, undergoing an expansion of its own in 2006, now occupies the location.

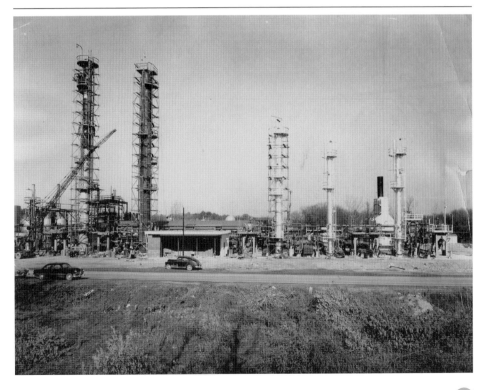

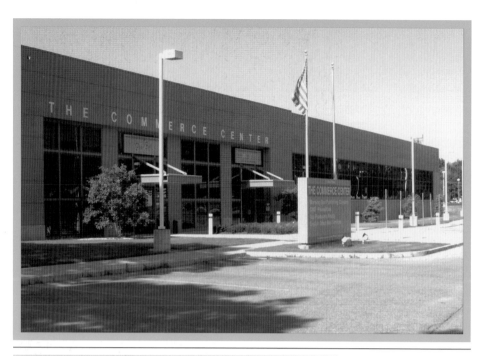

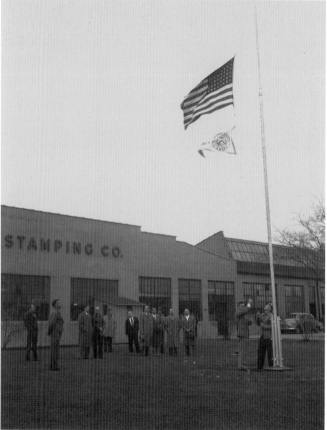

Originally constructed as a manufacturing facility for the local product Transport trucks in 1909, the building at 711 West Pickard Street in Mount Pleasant was American Enameled Products in 1926. It became the Ferro Stamping Company, a car parts manufacturer, left, in 1937, boasting many female employees making World War II tank parts. Vacant for years, the structure was resurrected by Sam Staples and is now the Commerce Center, above, housing offices of the *Mount Pleasant Morning Sun* daily newspaper and ancillary enterprises.

Longtime *Mount Pleasant Daily Times-News* publisher James Slattery poses in front of a new Linotype machine equipped with a perforated tape reader that automatically set lines of lead type for the newspaper in 1956. Executive editor Rick Mills of the *Mount Pleasant Morning Sun*, descendant of the *Times-News*, strikes the same pose 50 years later by a Linotype machine displayed in the lobby of the Commerce Center offices.

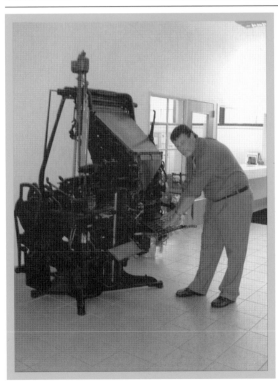

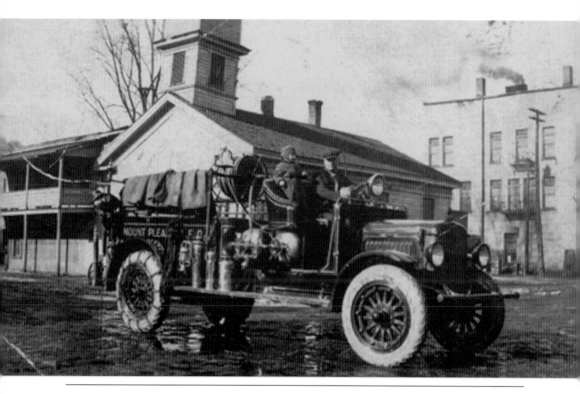

Here at the corner of Michigan and South Normal Streets (see page 31), Mount Pleasant's first motorized fire truck, a 1919 Transport, is taken for a spin by Roy D. Hafer Sr. (see page 53) with his toddler son Roy in 1920. A Transport truck was found in Ludington by Mount Pleasant resident Paul Habscher, was restored, and now occupies a showcase place of honor in front of the new fire and police departments at the Department of Public Safety building at 804 East High Street.

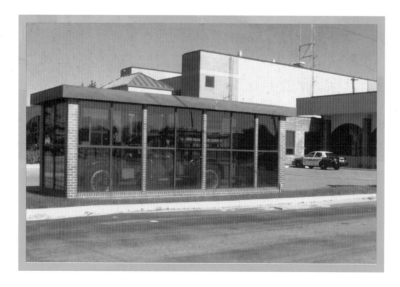

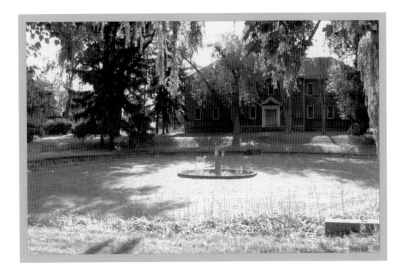

The fountain and flower gardens were constructed in 1891 at the United States Government Indian Industrial School on West Pickard Street, created to acclimate Native Americans to the "white man's world." First occupied in 1893, the building contained eight classrooms and an auditorium. The school operated with an average enrollment of 300 students until 1934. The property was then transferred to the State of Michigan. Functioning first as an institution for the mentally challenged, the facility has changed names and genre of clientele in recent years.

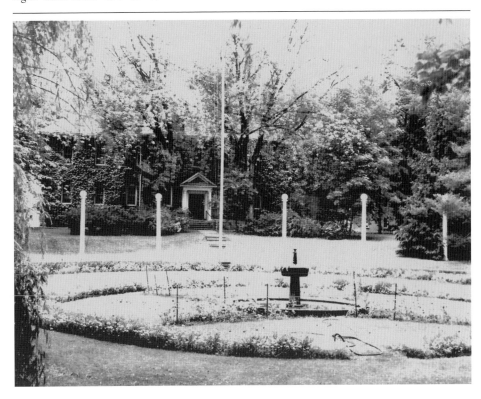

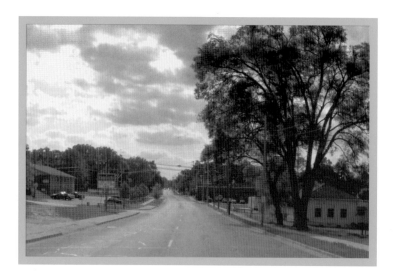

The Harris Milling Company, left below, and across the street the Independent Elevator, the Mount Pleasant Lumber Company, and the municipal waterworks, with railroad tracks beyond, made for a bustling commercial corridor along West Broadway Street. Both views look west from between Oak and Pine Streets. In 2006, above, the same scene shows low-income apartments on the left, along with the Water Works Spa, next to the entrance drive to the Mountain Town Station Brewing Company and Steakhouse in the old train depot (see page 88).

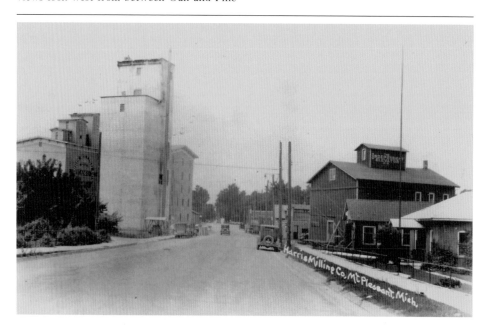

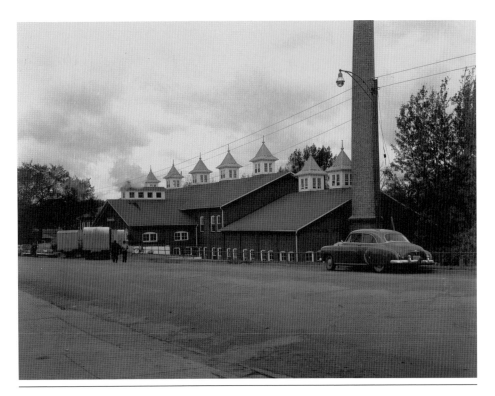

The Borden Condensery was built on the north side of West Broadway Street in 1907. The firm needed production from 1,000 cows to warrant starting a Mount Pleasant condensery. The area pledged production from 2,000 cows within a 10-mile radius of town. Borden closed the facility in 1960. For a period, the Bader Milling Company used it for fertilizer storage. Plans in 2006 call for a revitalization project that would bring the City of Mount Pleasant offices, among others, to the structure.

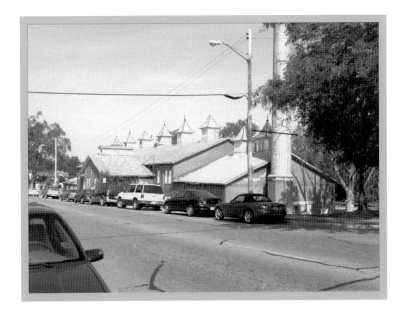

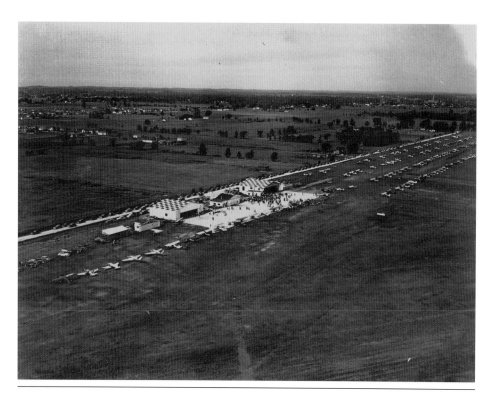

The Mount Pleasant Municipal Airport came into being in 1938 when Roosevelt Refinery deeded the company airstrip, established by oilman Walter J. McClanahan in the early 1930s, to the City of Mount Pleasant. The photograph above shows the airport during an early-1950s fly-in. Below, the same scene in 2006 illustrates the encroachment of the growing community into the area of the airport, including the lake behind the Holiday Inn.

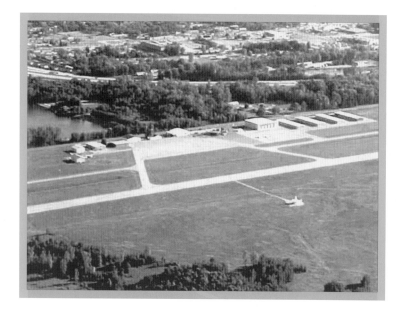

82

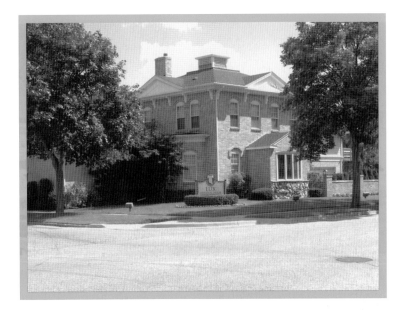

This early-1900s home on the northeast corner of Fancher and Broadway Streets at 503 East Broadway ultimately became the Rush, then Rush-Lux, and finally, in 1975, the Lux Funeral Home, illustrating that sometimes home and work can be in the same place. The Lux and the Helms (formerly Stinson) Funeral Home, at 330 South University Street, were Mount Pleasant's only funeral parlors until Clark's Funeral Chapel opened at 113 South Bradley Street in 2000.

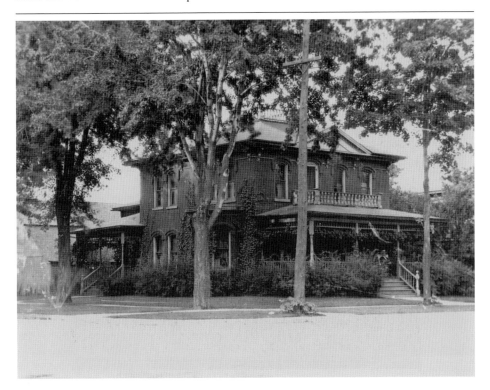

Small private home hospitals operated in Mount Pleasant until the Community Hospital opened in 1934 on the grounds of the former Native American school (see page 79). In 1943, Central Michigan Community Hospital opened at the Brown Street and Maple Street T on the east side of the city. In 2006, above, the original building is the centerpiece to a complex that includes its own growth plus the Isabella County Medical Care Facility and the Morey Cancer Treatment Center.

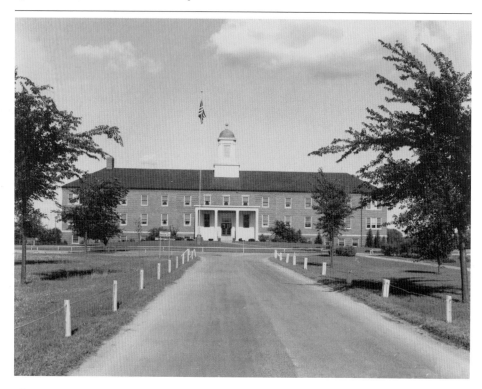

AT LEISURE

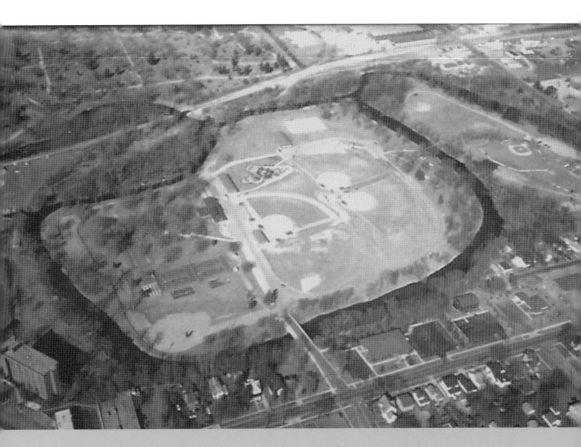

An autumn aerial look at Island Park near downtown Mount Pleasant shows the 1970s ball diamonds and tennis and volleyball courts built after the swimming pool (see page 89) and grandstand had been removed. The park has been a center for major community happenings for more than a century and now includes a skate park, shuffleboard courts, and the Michigan Vietnam Memorial.

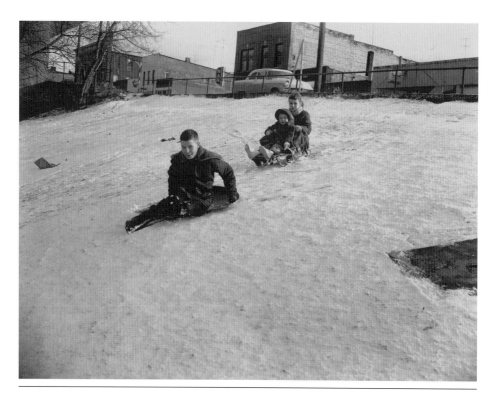

Generations of Mount Pleasant citizens carry fond memories of sliding down the Borden's "hill" on the north side of the 200 block of West Broadway Street. Great winter sport was had by "borrowing" a cardboard box from nearby downtown stores for a brakeless skid down the slope beside the condensery. Kids with sleds were considered sissies. The Mount Pleasant Beauty School (on the corner) and Cline Marketing (right) now occupy buildings across the street.

The North Main Street entrance of Island Park has been the access to hundreds of events, including the following: the Michigan Oil and Gas Expositions of 1935, 1936, and 1938, below; the Isabella County Fair (until the fairgrounds moved north of town); carnivals; family reunions; and for the last few years, the Mount Pleasant SummerFest, above. Gone are the grandstand, the Merchants Building, and the livestock barns but remaining is an outstanding park where a Thursday farmers' market takes place in season.

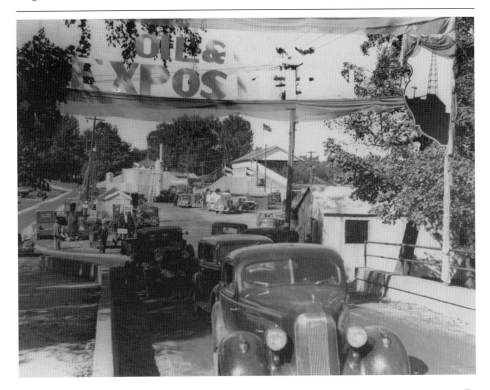

The Ann Arbor Railroad's Mount Pleasant passenger depot, located alongside the tracks at 506 West Broadway Street next to the Chippewa River, below, operated until the 1960s in that capacity then lay dormant for several years. The site was brought back to life with the opening of the Mountain Town Station Brewing Company and Steakhouse, above, a popular restaurant and brewpub that also serves as a railroad station for passengers on historic train excursions, offered periodically.

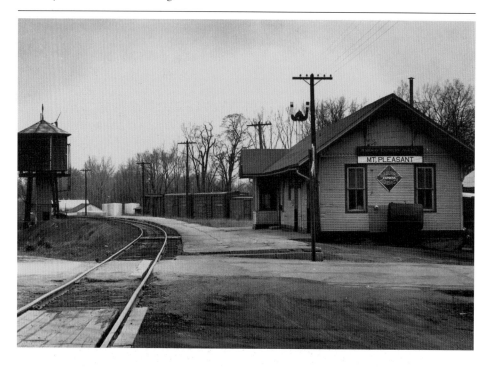

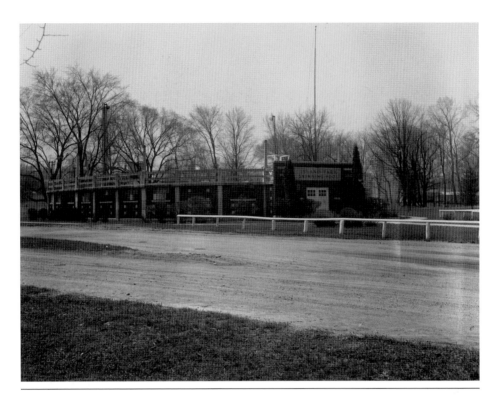

The Mount Pleasant municipal swimming pool served the community from the southeast quadrant of Island Park near downtown from the late 1930s until the early 1980s, when decentralization of the city and the professed high maintenance cost prompted discontinuation of operations, even though a similar pool in Lansing was refurbished and is still in use. As a further nod to the new world, the municipal skate and bicycle park now occupies the site.

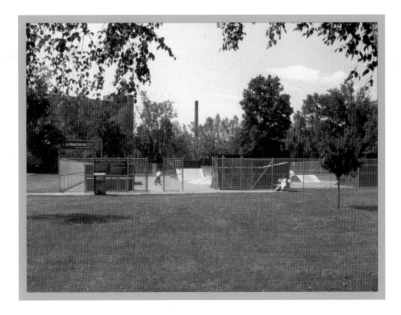

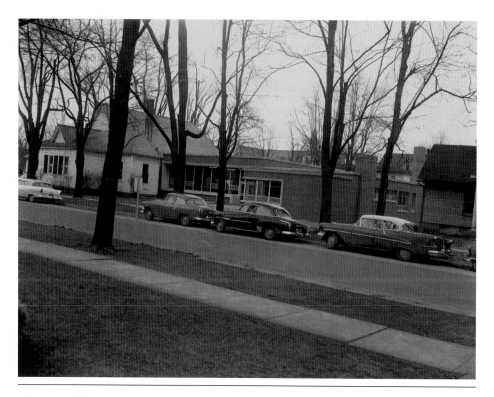

The Mount Pleasant Library, in the 300 block of South University Street, was originally housed entirely in the white wood building to the above left. The early 1950s brought the addition to the right and the placement of stone facing on the wood building. A brick structure later replaced the wood building, another addition was completed, and ultimately the former post office building was annexed to form the now Veterans Memorial Library in the Chippewa River District Library System.

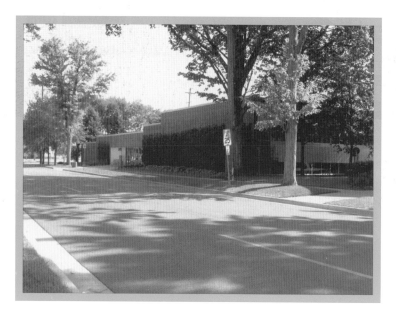

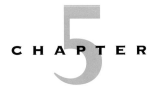

AT STUDY
AND WORSHIP

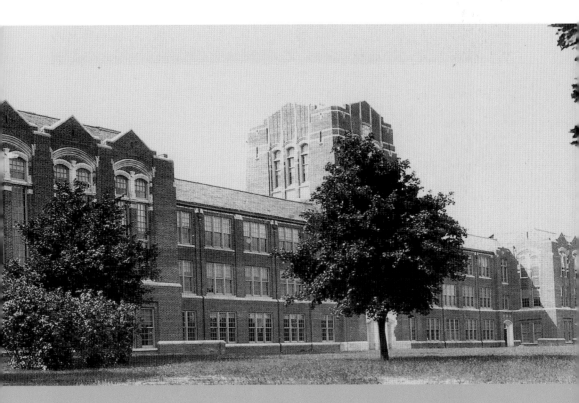

Central Michigan Normal School and Business College became a state school in 1895 and grew to today's Central Michigan University. The first classes were private and held beginning in 1892 at the southeast corner of Main and Michigan Streets. Warriner Hall has become the symbol of the now 20,000-student university, which occupies most of the city's far south end and is the second-largest Isabella County employer.

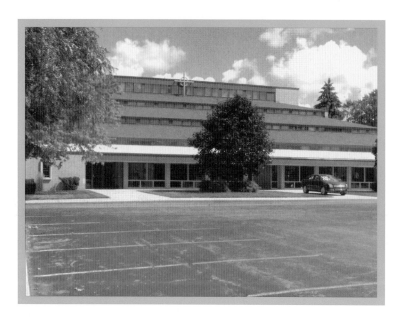

In the 300 block of South Fancher Street, the first Mount Pleasant High School was built in 1885 as Union School, with an addition constructed around the beginning of the 20th century. The Twin School, as it was then known, was replaced by the building below in the 1920s. It served as the high school until 1957, then as the junior high school until the mid-1960s, when an intermediate school building was constructed on South Bradley Street near High Street, and Sacred Heart Catholic Church, above, replaced it.

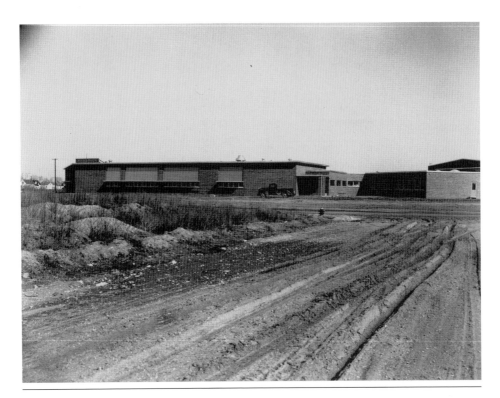

The new Mount Pleasant High School began construction in 1956 and opened to students during the 1958–1959 school year in the southeastern quadrant of the city. Built in a modern design with wings spoking out from a central courtyard, the high school underwent a huge expansion and building program in the 1990s to enhance the complex. It is home to the Oilers athletic teams, named in memory of the industry that shielded the town from the Great Depression of 1929 with the discovery of the Mount Pleasant oil field.

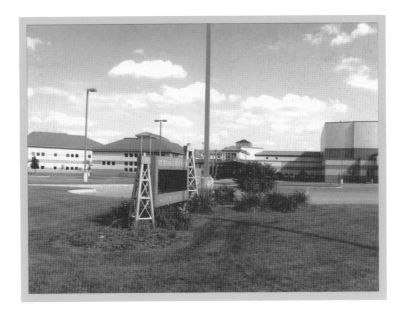

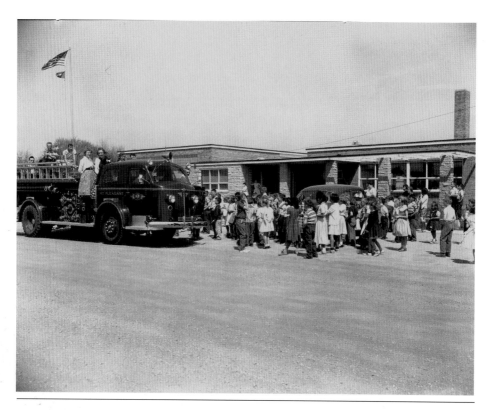

Pullen Elementary School, on Brown Street on the east side of town, is one of four outstanding elementary schools in the Mount Pleasant Public School System, which also includes Fancher Elementary (south side), Ganiard Elementary (west side), and Mary McGuire Elementary (far east side). A number of charter and religious schools round out the class offerings to kindergarten through 12th grade, including Sacred Heart Academy (see page 22), the Baptist Academy, and the Saginaw Chippewa Indian Academy.

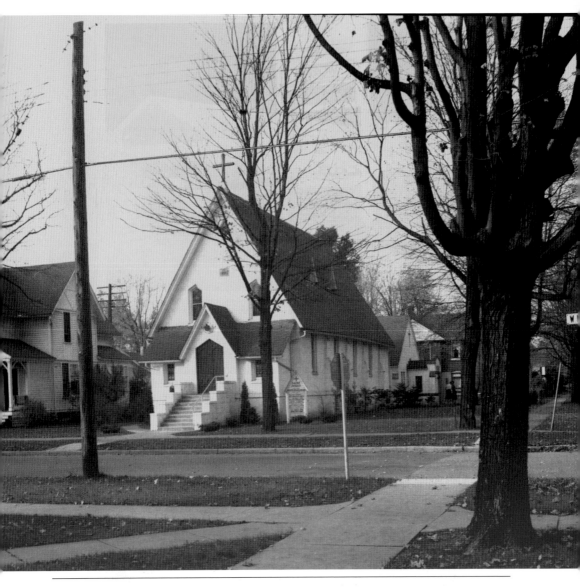

Among many fine Mount Pleasant houses of worship is the oldest public building in Isabella County and one of the oldest churches in the Episcopalian Diocese of Western Michigan: St. John's Episcopal Church. Located at the northwest corner of Washington and Maple Streets, it was built in 1882 for $4,300 by Mr. and Mrs. William N. Brown.

Across America, People are Discovering Something Wonderful. *Their Heritage.*

Arcadia Publishing is the leading local history publisher in the United States. With more than 3,000 titles in print and hundreds of new titles released every year, Arcadia has extensive specialized experience chronicling the history of communities and celebrating America's hidden stories, bringing to life the people, places, and events from the past. To discover the history of other communities across the nation, please visit:

www.arcadiapublishing.com

Customized search tools allow you to find regional history books about the town where you grew up, the cities where your friends and family live, the town where your parents met, or even that retirement spot you've been dreaming about.